North American Indians: A Very Short Introduction

Very Short Introductions available now:

For more information visit our web site
www.oup.co.uk/general/vsi/

Theda Perdue and Michael D. Green

NORTH AMERICAN INDIANS

A Very Short Introduction

OXFORD
UNIVERSITY PRESS

OXFORD

UNIVERSITY PRESS

Oxford University Press, Inc., publishes works that further
Oxford University's objective of excellence
in research, scholarship, and education.

Oxford New York
Auckland Cape Town Dar es Salaam Hong Kong Karachi
Kuala Lumpur Madrid Melbourne Mexico City Nairobi
New Delhi Shanghai Taipei Toronto

With offices in
Argentina Austria Brazil Chile Czech Republic France Greece
Guatemala Hungary Italy Japan Poland Portugal Singapore
South Korea Switzerland Thailand Turkey Ukraine Vietnam

Published by Oxford University Press, Inc.
198 Madison Avenue, New York, NY 10016

www.oup.com

Oxford is a registered trademark of Oxford University Press

Library of Congress Cataloging-in-Publication Data
Perdue, Theda, 1949–
North American Indians : a very short introduction /
Theda Perdue and Michael Green.
p. cm. — (Very short introductions)
Includes bibliographical references and index.
ISBN 978-0-19-530754-2 (pbk.)
1. Indians of North America—History.
I. Green, Michael D., 1941– II. Title.
E77.P425 2010
970.004'97—dc22
2010010247

1 3 5 7 9 8 6 4 2

Printed in Great Britain
by Ashford Colour Press Ltd., Gosport, Hants.
On acid-free paper

For Danny Bell, our friend and colleague

Acknowledgments

We would like to thank our colleagues in American Indian Studies at the University of North Carolina for their lively conversations and good company. Such colleagues are priceless; they make us better scholars and better people. So do graduate students like the ones we have taught over the years, especially those in the seminars on American Indian history that we have offered jointly. We are grateful to Rebecca Dobbs for the care she took in drawing the maps for this volume. Finally, we thank Susan Ferber, as fine a friend as she is an editor.

Contents

List of illustrations

Preface

A man we recently met asked us what we did for a living.
When we replied that we were historians and that our field was
American Indians, he replied, "So I guess you write that we done
'em wrong." We did not know exactly how to respond. Indeed,
"we"—Americans of European descent—have "done 'em wrong,"
but such a characterization of North American Indian history
belies the strength, creativity, and resilience of American Indians.
It makes them objects, not actors. In this brief introduction, we
do not shrink from depicting the horror of the European invasion
of North America or the devastating effects that it had on Native
people, but we also seek to capture the richness of their cultures
and the resourcefulness they employed in confronting the invasion.
Native people were not hapless victims. Instead, they met each
challenge with a determination to make it work for them. Often
they succeeded, at least for a while, and even when they failed, they
left a legacy of resistance that inspired the next generation.

This little book is part of a series that opens the door to a
particular topic. Like the others in the series, it is far from
comprehensive. Today there are 564 federally recognized Indian
tribes in the United States, on which this introduction focuses.
Each has its own government, history, and cultural traditions. In
addition there are a host of state-recognized tribes, unrecognized

Indian groups, and individuals who claim Native ancestors. There is no way that we can include all of them. We have tried to convey a sense of the diversity of Native America, to describe specific events that reflect common themes, and to present a complex history in a way that is intelligible to readers seeking a simple introduction. We do so with the survival of American Indians always in the forefront of our minds. Despite the fact that "we done 'em wrong," often in unimaginable ways, Indians are a vibrant part of twenty-first-century American life, not merely as individuals but as citizens of sovereign nations.

We have been teaching and writing about American Indians for nearly forty years (that's separately—nearly eighty years together). Theda Perdue began her career at Western Carolina University, where she helped establish a Cherokee Studies Program and taught on the Eastern Band of Cherokees' reservation, and Michael Green chaired the Native American Studies Program at Dartmouth College. We went on to other jobs at other universities, but the one constant thread was our determination that the academy become a comfortable place for Native people and that their histories and cultures enter in the curriculums of the institutions where we taught. Nowhere have we found anyone as dedicated to achieving those goals than at the University of North Carolina. Theda had known Danny Bell since the 1980s when he worked for the North Carolina Commission for Indian Affairs, and Mike came to know him when we first came to UNC in 1995 as visiting professors. Ironically, Danny, who is Lumbee and Coharie, was working for Study Abroad, but his mission was getting the university to recognize its obligation to the nearly 100,000 Indian people who lived in North Carolina. Hiring us became part of his scheme. He succeeded, and he moved with us in 1998 to American Studies, which eventually became home to the academic program in American Indian Studies. It is appropriate for us to dedicate this book to Danny Bell, not just because of what he has meant to us personally and professionally, but because his own history and that of his people mirror its themes.

Chapter 1
Native America

In October 1492, Christopher Columbus encountered the native people of a small island in the Caribbean. He thought he was in the East Indies, so it made sense for him to refer to the people he met as "*los Indios*," or Indians. Even after Europeans realized that Columbus was mistaken, the name stuck. Thus the native people of the Americas are, collectively, Indians. But the people of the Americas had no collective term for themselves. The names Native Americans call themselves often can be translated as "The Real People," "The Principal People," simply "The People," or perhaps the people of a particular place.

As each group had its name, it also had its own unique history. Communicated orally from generation to generation, these histories often begin with the creation of the world. The Cherokees, for example, tell of a time when the world was only water until a beetle grabbed some mud and brought it to the surface to make land. In the Iroquois story, the diving animal spread the mud on the back of a turtle so that Sky Woman, who had fallen through a hole in the sky, could have a dry place to live. The histories of the many Pueblo groups and other societies of the desert Southwest begin with the migration of their ancestors from deep within the earth to a cave or other kind of portal on the surface. The stories told the people who they were and reminded them that the place where they lived was theirs, that it had always

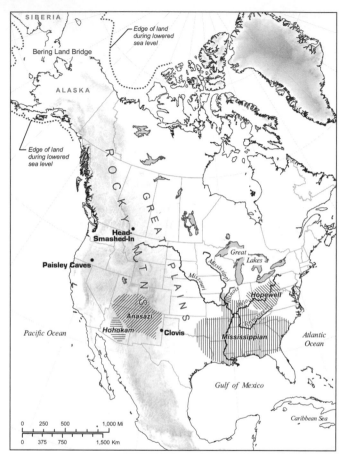

1. Early North America.

been theirs, and that it was the place where they were meant to be. The stories underscore the distinctiveness of each group and remind us how inadequate it is to think, as Columbus did, of Native Americans collectively. They have become Indians in our thinking and our literature, but in reality they have never been any such thing.

Europeans, once they realized that Columbus's geography was wrong, were dumbfounded by the idea that two continents of people, perhaps seventy-five million of them, had escaped their notice. The Bible, which Europeans believed told the full story of creation, could account for neither America nor American Indians. In the centuries since Columbus, there have been many attempts to explain the peopling of the Western Hemisphere. Unwilling to accept Native creation stories as "true," most scholars have become convinced that the ancestors of American Indians came to America from Asia, across the Bering Land Bridge, which periodically connected Siberia and Alaska during the last ice age.

Beginning about 100,000 years ago, according to this theory, global cooling caused water to freeze into enormous glaciers that covered much of North America. The glaciers trapped the rainwater, caused the level of the oceans to fall, and exposed the land beneath the Bering Strait. This land bridge was exposed twice, from 75,000 to 45,000 years ago and again from 25,000 to 11,000 years ago. During these periods of glaciation and lowered sea level, the Pacific coastline of North America was some sixty miles farther west than it is now. Pleistocene animals such as wooly mammoths, giant bison, and sloths grazed across the land bridge, and the hunters who exploited them, the ancestors of Native Americans, followed. It is not clear how the animals and humans made it from Alaska south—perhaps during periods when the two North American glaciers did not meet, they traveled along the eastern slope of the Rocky Mountains, but they may also have come down the coast. However it happened, the evidence suggests that the Paleo-Indians, the ancient ancestors of Native Americans, and their game, somehow made the trip from Asia to South America.

The earliest well-documented Paleo-Indian culture is called Clovis, named for a site near Clovis, New Mexico, where distinctive spear points were discovered in the 1930s in association with the remains of extinct Pleistocene bison. Dated to

about 13,500 years ago, the Clovis culture has long been described as the first Native culture in America. Recent discoveries suggest that that may not be the case. Monte Verde in Chile is a thousand years older, as is the Paisley Caves site in Oregon that has recently been dated to 14,300 years ago. These are isolated finds, however, and are not well documented or understood. Clovis, on the other hand, is well known. Identified by the unique design of spear points and found widely in North America, Clovis represents a hunting culture that exploited Pleistocene animals, especially bison and mammoths, in locations that stretch from coast to coast. While not numerous, Clovis sites are the remains of hunting camps and suggest that people followed their game in small groups over great distances, camping in temporary shelters. They killed and butchered their prey, gathered locally available plants, manufactured their tools and weapons, and adapted successfully to changing conditions.

The most dramatic change occurred about 12,900 years ago with the extinction of the giant Pleistocene animals. Perhaps overhunted by Clovis hunters, perhaps the victims of climate change caused by global warming, the melting of the glaciers, and the attendant alteration of plant life that provided forage, perhaps due to a combination of factors, the animals simply disappeared. Clovis sites, marked by their signature stone points, also disappeared. The people, of course, did not disappear. They adapted.

For the next several thousand years, climate change drove culture change. The warm-up that melted the ice sheets did more than inundate the Bering Land Bridge. Melting water from the glaciers cascaded into North America, creating massive lakes and new rivers. For a time, the land became significantly wetter, which encouraged various species of grass and trees. But continued global warming made the climate drier and warmer, the huge lakes shrank or dried up, and ultimately the regional ecosystems of modern North America began to take shape. The changing flora of America

changed the fauna. As the giant Pleistocene animals disappeared, deer, caribou, and a smaller bison known colloquially as buffalo prospered. In place of Clovis came new cultural manifestations marked by differently shaped, styled, and sized projectile points and tools. Designed to meet the needs of mammoth hunters, the beautiful and finely crafted Clovis points were simply too large and cumbersome to efficiently kill smaller, fleeter game. Furthermore, as human populations grew and learned to respond to more regionalized environmental characteristics, they changed their cultures so that they too could prosper. During the first few thousand years following Clovis, three regional culture areas became apparent—the Far West, the plains, and the East.

Around 11,000 years ago, the plains became an arid grassland populated by buffalo that Indian bands hunted with spears. These bands were probably small family-size units with intimate knowledge of both the terrain and the habits of buffalo. Periodically, bands gathered together to conduct more labor-intensive communal hunts, accomplished by driving groups of buffalo into impounded arroyos or over cliffs. "Buffalo jumps," such as "Head Smashed In" in Alberta, abound on the plains. Some of them, judging by the piles of bones dozens of feet deep, were used for thousands of years. Driving buffalo while on foot was a difficult, dangerous business that required careful planning, many people, and much hard work, but the payoff, in the form of thousands of pounds of meat, could be dramatic.

Such kill sites make it possible to speculate about the social and political organization of these people. The large numbers needed to accomplish a successful jump and dress the dozens, perhaps hundreds, of carcasses probably required a level of leadership, planning, organization, and supervision that suggests governance. Scholars imagine a scenario in which knowledgeable elders, experienced hunters, and probably individuals with religious power surfaced to decide on arrangements and supervise the work of the dozens, perhaps hundreds, of people involved. This kind of

political organization was situational, however, and would dissolve when the hunt was over and constituent bands returned to their regular range. But during the period when they were together, the bands probably intermarried, linking the people in an expanding kinship network that would form the basis for future hunts.

The people who lived west and east of the plains were also hunters of game and gatherers of plants. Like the people of the plains, their lives and cultures were shaped by the ecosystems in which they lived. And like them, they organized themselves in the ways necessary to maximize the efficiency of their work and thus their survival. On the Pacific coast they learned to fish and kill sea mammals. In the East they hunted deer, turkeys, and other forest animals. Everywhere, as they deepened their knowledge of the places where they lived, they exploited the plant life locally available.

Post–Clovis Indian people grew rapidly in numbers. Indeed, along with the influence of climate, flora, and fauna, an important driver of change and adaptation during this long history was population growth. Groups expanded into new places, their camps grew larger and more numerous, and the areas where they lived shrank. Instead of ranging long distances, they developed patterns of movement over smaller areas and exploited animal and plant resources more efficiently. Long-term relations with and claims to specific places emerged.

More substantial dwellings and cemeteries, beginning about 6,500 years ago, make this process visible to scholars. As people returned to the same places regularly and lived in some of them for longer periods, it became worth their effort to substitute houses for temporary shelters like brush huts or tents. Similarly, they began to bury their dead in cemeteries. Houses provide archaeologists with useful evidence about subsistence patterns and family life while cemeteries contain important information about social and political organization. When they buried their dead relatives in a

special place, people laid claim to that place. The religious rituals that may have accompanied burial made the relation between people and place sacred. Perhaps more importantly, people often treated the death and burial of specific individuals differently. Some were buried with valuable goods, tools, and weapons, while others were not. This indicates that some people were more important than others, and status differentiation has important cultural implications. It suggests, for example, that a group had grown large enough, and thus complex enough, to need some form of organized political system capable of providing leadership, a means of selecting leaders, and social rules.

While hunting animals and gathering plants remained vital segments of the many subsistence economies, some groups of Native people, perhaps in response to ongoing population growth, embraced new strategies of food production. None was more important than agriculture. Knowledge of the cultivation of corn, beans, and squash came to the dry, harsh world of the American Southwest from Mexico between 2,000 and 3,500 years ago. Initially, people used this knowledge to produce crops that could supplement their regular hunting and gathering routines. In the process they began to construct storage facilities among their houses, and gradually their residential and cultivation settlements took on the character of villages. They began to make pottery vessels for storing grain, hauling water, and cooking stew. Because pots are heavy, fragile, and do not travel well, they are markers of permanent settlement.

Two remarkable southwestern cultures emerged from this agricultural revolution. One, the Hohokam, flourished in the south Arizona desert between 900 and 1500 CE. The key to its success was an extensive irrigation system that drew water from the Salt and Gila rivers and dispersed it through a network of canals. The construction and maintenance of the canals and the adjudication of water rights required a centralized political system. The platform mounds, ball courts, and large adobe brick

buildings at Hohokam sites suggest a ranked social system to parallel political hierarchy.

The Anasazi culture, centered in the Four Corners region northeast of Hohokam, flourished during the same time. Also dependent on agriculture, Anasazi people lived in an area that was wet enough to permit farming without massive irrigation. Amazing architects, the Anasazis built towns that have become, in the form of Chaco Canyon and Mesa Verde, places visited by millions of tourists. But by the fifteenth century both Hohokam and Anasazi had fallen into decline. The people scattered out and created new communities in the deserts and valleys of New Mexico and Arizona. Their descendants form the Pueblos, the Pimas, the Tohono O'odham (Papago), and other Native societies of the Southwest. Why these cultures came to an end is not clear. Possibilities are many: prolonged drought, a shortage of wood for building and fires, and rising salt levels in Hohokam canals that killed the crops. Whatever happened, the people remained in the country, they continued to plant and harvest corn, beans, and squash, and their cultures, ever vital and adaptive, continued to change.

Unlike the people of the Southwest, who imported their knowledge of agriculture from Mexico, Native easterners domesticated squash, sunflowers, and other plants on their own about 3,500 years ago. Initially, agriculture was largely confined to the area where the Ohio, Tennessee, Illinois, and Mississippi rivers converged. About 200 BCE cultivated crops increased in importance in the subsistence economies of these people, and four centuries later farmers in this riverine region added corn, the knowledge of which apparently arrived from the Southwest or Mexico. No longer supplementary to a more important hunting and gathering program, agriculture began to characterize a new cultural development termed "Hopewell." Unlike many agriculturalists, Hopewell people did not organize themselves in villages. Instead they built small farmsteads, probably of extended

8

families, that stretched for miles along the rivers and streams of the region. Some form of political/ceremonial organization bound them together, the results of which are visible in the massive earthworks they built. Hopewell people interred elites in burial mounds with a wealth of goods, much of which came from distant places via complex trade networks. Other earthworks have geometric or animal shapes. The purpose of these constructions seems to have been ceremonial. Hopewell mounds are particularly common in southern Ohio, the most famous of which is a huge snake, well over 1,000 feet long, with an egg in its mouth. After about 400 CE, the Hopewell culture disintegrated and many of its people migrated elsewhere. Some went to the Missouri River and its tributaries where they established a network of agricultural villages that extended as far as today's North Dakota.

By the time of the demise of Hopewell, the knowledge of cultivation was spreading throughout eastern North America. Corn and squash, later reinforced with beans, became the chief crops. By about 800 CE, Native farmers as far north as New England and the Great Lakes had developed varieties of corn that thrived in a short growing season. But the true heartland of corn agriculture became the Southeast, the region of the Mississippian culture.

Emerging between 800 and 1000 CE and lasting until the sixteenth century, the Mississippian culture was the most dramatic, complex, and sophisticated Native culture in America north of Mexico. Several characteristics define it, the first being the central importance of agriculture that permitted the accumulation of food surpluses that could sustain large stable populations. This abundance encouraged the development of a hierarchical social-political system dominated by a powerful chief supported by an array of lieutenants and priests. The construction of mounds, often huge, was integral to the maintenance of hierarchy, the performance of ceremony, and the demonstration of both spiritual and chiefly power. Mississippian culture is generally

thought to have originated in the southern half of the Mississippi Valley, but Mississippian sites, visible today by the mounds, extended east into Georgia and west to eastern Oklahoma. The common feature of these communities is their location on rivers whose flood waters deposit silt and create levees that can easily be cultivated as fields.

Since farmers work much harder than hunters and gatherers, it is not fully clear why Native Americans began to domesticate plants and develop agriculture, but there is a definite correlation between agriculture and population growth. Which was cause and which was effect is a matter for debate, but the connection of the two had a revolutionary impact on the lives and histories of most of the people of North America. Indeed, at the time when European explorers first began to enter and describe Native America, it was primarily an agricultural world. The people on the Pacific coast from California to British Columbia did not farm because the natural environment was so rich they did not have to, and neither did those who hunted on the plains, in the Great Basin, or to the far north. But everywhere else, in the desert Southwest, in the Missouri River system, and east of the Mississippi River from the Great Lakes to the Gulf of Mexico, the cultivation of corn, beans, and squash, revered by the Iroquois as the Three Sisters, produced the bulk of the food for Indian people.

Except in the Southwest, where men and women shared agricultural labor, farming in Native America was largely the work of women. Indeed, it is likely that women were the inventers of agriculture in North America. In the division of labor that supported the subsistence economies of all Native people, the contribution of women was the gathering of plants. They came to know the plants, what they were good for, where and when they could be found, and everything else about them. One scenario is that as they gathered the plants they favored, they cleared the area around them of competitors, enabling the privileged plants to thrive. Another scenario is that as women carried seeds home,

some spilled, germinated in new places, and revealed the secret relationship between planting seeds and producing crops. Over time, as agriculture became normal, women cemented their relationship with plants with special prayers and songs. Nothing dramatizes this as forcefully as the Cherokee story about Selu, the first woman, whose name is the word Cherokees use for both corn and woman. Selu produced corn from her body, giving it birth, and with it assured that her descendants would always have food. The blending of these two ideas, cultivation and birth, production and reproduction, encapsulated the essence of womanhood.

While women gave life, men took it away. Hunting and warfare defined masculinity, and both required specialized knowledge. As hunters men learned not just the habits of game but also the ritual observances that made game plentiful and honored the spirits of the animals they killed. The contributions of men to the subsistence economy of their people, while different from that of the women, was necessary and valued as were their skills as warriors. Men went to war for very different reasons than they did for hunting, but warfare was also essential to the survival of their people. Because Native people waged war against outsiders, diplomacy and foreign trade also often came under the purview of men.

In every facet of life, Native cultures were intensely gendered. In some groups women and men spoke different dialects of their language, and each was astonishingly ignorant of the way the other fulfilled gender-specific responsibilities. Yet neither could survive without the other. Their differences balanced one another and formed one of the many essential dualities that characterized virtually every Native culture in North America.

The Sioux anthropologist Ella Deloria wrote, "All peoples who live communally must first find some way to get along together harmoniously and with a measure of decency and order." Native societies did this through kinship systems, which often were extremely complicated because they included biological relatives,

relatives by marriage, and people in biologically unrelated groups understood, nevertheless, to be relatives. Kinship shaped the ways each person interacted with other people in daily life and provided the social rules by which everyone lived.

All Indian societies had kinship systems, but all did not figure them in the same ways. Some, particularly the hunting and gathering societies in the plains and far north, reckoned descent bilaterally. In other words, they understood themselves as descending from, and belonging to, the families of both mother and father. Patriliney and matriliney, the other common methods of determining kin, were much more common. As the names suggest, these systems restrict descent and thus kinship to either father's family or mother's. Matrilineal kinship systems were prevalent among the eastern and southwestern farming peoples; patrilineal systems were most common in the middle of the continent where groups tended to depend less on agriculture for their subsistence base. Worldwide, matrilineal descent is rare, which makes its prevalence in North America somewhat remarkable. Scholars speculate that this practice reflects women's economic importance as the ones primarily responsible for farming.

No one can trace definitively the history of kin-based social organizations, but many Native groups have stories that describe an ancient time of social disorder when there were no rules of behavior and all was confused and dangerous. Seeing the conflict and chaos, spirit forces intervened and gave the people their kinship system. Order and harmony replaced chaos. In the retelling of these stories, the people reaffirmed the importance of the rules of kinship as well as the beneficence of the spirit world. Because the purpose of the kinship system was to assure that the community survived and prospered with a minimal level of conflict, the central idea of the network of relationships was reciprocity.

The rules of kinship were both demanding and simple. In daily life one respected, deferred to, cooperated with, helped, shared with,

and gave to others in the realization that they would give back. It was a social system but it had clear economic overtones. By putting the needs of others before those of oneself, every member of the community both contributed and was cared for. Thus one defied one's kinship responsibilities at one's peril. No crime against the community was worse than selfishness, no attitude more antisocial than arrogance, no behavior more loathsome than argumentativeness. The individual who behaved thus, in the small, tightly knit world of Native communities, quickly found himself shunned, shamed, isolated.

The reciprocal relationships that marked the kinship systems of American Indians could be seen in virtually any arena of life. Kin hunted together and shared the meat, they farmed together and shared the crop, they worked together and lived together. In times of trouble, kin networks organized war parties and domestic security. In case of an unnatural death, kinsmen took a life from the family, clan, or village of the perpetrator. Probably, this "law of blood" rarely applied within the community—the people did not kill one another. But it was central to foreign relations because foreigners were outside the kinship system, uncontrollable and potentially dangerous. This meant that the normal relationship with foreign groups was war. Peace could be established only by incorporating foreigners into the kinship system via adoption. Such fictive kinship arrangements made it possible for people to interact across tribal boundaries to trade or ally against common enemies.

Kinship provided the basis for political organization although governing systems varied. Some groups lived in small, mobile hunting bands, and others lived in large urban settings, but most lived between these extremes in modestly sized sedentary agricultural villages. The problems of governance were particular to each living arrangement, and the solutions tended to rest on leaders supplied by especially prominent, often elite, kin groups. The rules of kinship meant that the members of such a kin group

served as the power base of the leader. They supported their kinsman, carried out his policies, and protected his authority. The leader reciprocated by bestowing honors and gifts on his loyal relatives. As long as the people respected his leadership qualities, credited him for his successes, and gave him their loyalty, they received in return his generous bounty. If things went badly they looked elsewhere for leadership. In most Native political systems, successful performance modified but did not discredit the principle of inheritance.

Nothing was more important to achieving success and prosperity than the preservation of a strong relationship with the spirit world. As with all people, Native Americans found themselves living in a world filled with questions. As they sought answers, they developed ideas that centered on the pervasive existence of spiritual power. Ranging from the stories about creation to the problems of survival in daily life, they came to believe that spiritual power not only existed, it could be appealed to. Ceremonies of supplication and thanksgiving marked the year for virtually all Native peoples. In many groups, a professional priestly class directed these rituals but songs, dances, and prayers were not limited to public performance. Part of what defined the special relationships between women and plants and men and animals was that women knew the songs that the crops liked to hear, and men could communicate with the spirit guardians of the animals. Many groups believed that individuals, primarily males, needed to establish personal relationships with a spiritual guide and protector. One did this through fasting, suffering, and prayer, the result of which ideally would be a vision in which the protector revealed itself.

The pattern of understanding, probably best understood as a belief system rather than as religion, was fundamentally practical. Designed to avert calamity and assure survival, there was no dogma. But there was experience. People needed to eat, and experience showed that hunters and farmers who performed

the necessary rituals produced food. People who got sick needed to get well, and experience showed that healers who prayed as well as prescribed often achieved success. Because Native belief systems were practical and inclusive, they were also dynamic. New rituals, ceremonies, prayers, songs, and dances could always be incorporated into the thought of people who believed that survival and success in life depended on a vibrant partnership between themselves and the powers of the spirit world.

Despite similarities, the cultural diversity of American Indians remains one of the central characteristics of Native America. All groups of Native people used the rules of kinship to organize their societies, but the rules were not uniform in detail or performance. All had political organizations and systems of governance, but they ranged in character from highly centralized and hierarchical to decentralized and situational. All had belief systems that recognized the pervasive controlling influence of the spirit world, but their means for beseeching and benefiting from that power differed widely because groups had varied needs that demanded particular rituals and ceremonies to communicate their wishes to a panoply of formidable nonhuman beings.

The most spectacular example of diversity is language. Linguists speculate that at the time of the European invasion in the early sixteenth century, some four hundred different languages were spoken in North America. There may have been more, but there is no way to know how many became extinct before scholars began to notice. Of this number, about half remain alive and forty-six are spoken by enough children to suggest that they will survive well into the future. California was one of the most linguistically diverse places in the world. Perhaps as many as eighty mutually unintelligible languages were spoken there. Scholars think of culture as a mental construct. Since language is the means by which people think and order their understanding of their world, the diversity of language is a strong indicator of the diversity of Indian cultures.

When Europeans began their invasion of America, Native Americans had long and dynamic histories, a rich and diverse array of cultures, and satisfying ways of life. People had had millennia to figure out how to live and prosper on this land. But the European invasion demanded a host of adjustments. None of them carried the range of complex, transformative, and deadly implications that attended the introduction of epidemic disease. Without statistics, demographic history is inexact at best, but population estimates for North America at the time of Columbus currently range from five to seven or eight million people. Census records for the United States in 1890 reveal a Native American population of about 250,000. Explanations for such a mind-numbing collapse in numbers cover the gamut from genocide to dislocation to starvation to stress. But none compares with the documented impact of smallpox that, for example, killed more than 90 percent of the Mandans during the summer of 1837. Along with measles, influenza, whooping cough, several kinds of plague, and a number of other maladies, smallpox literally decimated Native America. These were deadly epidemic diseases in part because Indians had no experience with them, had developed no immunity for them, had devised no procedures for dealing with them. When smallpox struck a village virtually everyone got sick, leaving no one to provide needed care.

Most of the deaths occurred outside the view of Europeans, and the human suffering and loss are not recorded in detail in the historical record. The broader effects of disease are becoming better understood because we are learning that the strike of an epidemic left nothing untouched. Political and social systems collapsed and had to be restructured, and ceremonial systems often lost credibility and had to be reconfigured. Valuable knowledge died with the elders, necessary skills died with the young adults, mothers and fathers left their children orphans, and when the children died, so did the future. The changes were so comprehensive, the readjustments so massive, the level of human suffering so catastrophic, we can only guess what the experiences

of the people might have been. To make things even worse, the epidemics reappeared continually. If, as one scholar has suggested, there was on average an episode of epidemic disease every four years somewhere in Native North America from 1500 to 1900, then the terrifying sweep of unaccountable and unstoppable death must be understood as a constant backdrop to the history of American Indians.

Chapter 2
The European invasion

America, and the people of America, raised all sorts of questions in Europe. Spain confronted them first. What rights did Spain have to claim and exploit the country that Columbus found in its name? What rights did the people who lived there have that Spain must recognize and respect? What privileges did Spain have in relation to other sea-faring nations that might follow and compete? Seeking answers, the Spanish crown appealed to the only supranational power in Europe, the pope.

A series of pronouncements and diplomatic initiatives from the pope became known in international law as the doctrine of discovery. Designed in part to clarify the power of Christian "princes" over the lands of non-Christians that might in future come to their attention and in part to prevent bloody conflicts between competing princes, the doctrine of discovery authorized any such prince to exercise dominion over any territory not already subject to the claim of another Christian prince. In the 1490s, the nations most actively engaged in long-distance commercial exploration into non-European waters were Spain and Portugal. To clarify matters enunciated in earlier papal pronouncements, in 1494 Pope Alexander VI supervised the Treaty of Tordesillas between the two powers. Drawing a line west of the Azores, which unexpectedly struck the bulge in South America and thus endowed Portugal with Brazil, the agreement

divided the world into two parts and assured Spain's right of discovery to most of the Western Hemisphere. The right of discovery did not distinguish between Europe and the rest of the world; rather it demarcated the Christian from the non-Christian world. In return for the right to possess, exploit, and dominate America, the pope expected Spain to bring its people into the Christian fold.

By the late sixteenth century, both France and England had rejected the right of discovery as inadequate. Eager to exploit the riches of America themselves, they demanded a modification, which became in international law the right of conquest. Their point was not necessarily actual military conquest, it was dominion. The Spanish could not legally claim a country that they did not occupy and control. Preoccupied with its holdings in Central and South America, Spain chose not to challenge seriously the actions of France and England to carve out claims in North America. Thus the right of discovery, modified later by the right of conquest, became the legal basis for the invasion and occupation of non-Christian America by the forces of the Christian princes of Europe. As the successor to the claims of all three imperial powers, the United States holds the lands within its borders by the same rights of discovery and conquest.

For American Indians, the distinction between right of discovery and right of conquest was minimal. According to European international law, claims to and occupation of their lands were legal. The histories of these claims and occupations are different in many ways, shaped as they were by the interests, expectations, and cultures of the three contending Europeans, but in the final analysis the critical questions can be answered only by studying the cultures, interests, and policies of the many Indian groups of North America.

The Spanish occupation of the Americas began in the late 1490s with the establishment of settlements in the Caribbean and

quickly spread to the mainland. Exploration led to permanent settlements, and in North America the Spanish occupied Florida in 1565 and New Mexico in 1598. The French and British soon followed with colonial outposts in Canada and Virginia. The Spanish never forgot their obligation to Christianize the Indians they encountered, and both the French and British, to varying extents, followed suit, but the compelling theme of the European colonial invasions and occupations of America was economic. After the Spanish stumbled upon the vast riches of the Aztecs in Mexico and the Incas in Peru, no dream of gold, silver, and jewels could be dismissed as impossible.

Acting on this hope, between 1539 and 1542 Hernando de Soto led an army of exploration through the Southeast, and Francisco Vásquez de Coronado did the same in the Southwest. They encountered dozens of Native villages, intimidated, enslaved, and killed thousands of people, and recorded for future use an enormous amount of information. But they found no gold. Their dreams were just dreams, and ultimately the Europeans had to settle for the profits derived from trading with Indians, raising livestock, or growing crops. The meaning of this economic truth for the Indians of North America is that from the beginning the focus of contention between themselves and the Europeans was the land, its resources, and its productive potential.

Pedro Menéndez de Avilés founded the first permanent European settlement, St. Augustine, in Florida in 1565. Florida was home to many Indian groups but it was the Timucuas who lived adjacent to St. Augustine. Organized into at least thirty-five autonomous chiefdoms and numbering an estimated 200,000 people, the Timucuas raised crops of corn, beans, and squash. They also gathered wild plants and nuts, hunted deer and other animals, and harvested shellfish and other sea creatures. Timucua political organization was hierarchical, organized by kinship, and centered on the chief. He provided political and military leadership, conducted foreign relations, and managed the economy by

collecting tribute and then redistributing it to high-ranking relatives and supporters. The Guales, also hierarchical in social and political organization, lived just north of the Timucuas, and in 1566 Menendez established Santa Elena on Parris Island in Guale country. Before the end of the century, the Guale rebellions forced the Spanish to withdraw from their territory.

Juan de Oñate organized Spanish settlement in New Mexico in 1598. The Indians of the Rio Grande Valley of New Mexico were also farmers, hunters, and gatherers of wild plants. Like the Timucuas, they lived in autonomous villages, perhaps sixty to seventy of them, and numbered approximately forty thousand people. The Spanish referred to these villages as pueblos, the Spanish word for village, and the term has remained as the signifier of the peoples and cultures of the region. The villages were composed of multistory houses made of stone, perhaps surrounded by a wall, and built in the midst of large irrigated fields of corn and beans.

The Spanish populations of both Florida and New Mexico were very small, and they relied on the labor and productivity of the Indians to support them. Fashioning the Indians into a usable labor force was the work of the missionaries, who linked complete Hispanicization to conversion. Both were necessary preliminaries to the incorporation of the Indians into Spanish American society as a class of laboring peasants. In Florida missionaries learned that if they exploited the Timucuas' political system by levying labor through the chiefs, they could be much more successful. This system reinforced the authority of the chiefs while the people, used to following chiefly directives, did the work.

The mid-seventeenth-century Spanish mission system in Florida extended west to the large and rich chiefdom of Apalachee, the site of present Tallahassee, Florida. Apalachee chiefs, like Timucua chiefs, could be counted on to cooperate as long as the Spanish respected their authority. The Spanish at St. Augustine

ate corn and meat produced by Indians and carried to town by Indians. Other Indians built the road between Apalachee and St. Augustine, still others built houses and public buildings in St. Augustine, and yet others built and rebuilt the huge Castillo de San Marcos that guarded St. Augustine from foreign enemies. In the 1680s Indian raiders from farther north began to attack the missions, killing or capturing Indians who lived there. By 1705 raids had destroyed the missions. The Indians were scattered into refugee camps around St. Augustine, dead, or enslaved in the English colonies.

In New Mexico, Indians built and maintained the many missions, tilled the fields that fed the missionaries, paid tribute to the governors in labor and produce, and worked as cowboys on Spanish ranches. With little spare time to produce for themselves, starvation became commonplace. Indeed, food became an important incentive to join a mission. But New Mexico was beset by periodic feuds between the church and the government, and the burden on the Indians fluctuated. In the 1670s, after a period of relaxation, a new regime revived efforts to stamp out Pueblo culture. The priests desecrated holy places, disrupted public ceremonies, and tortured Pueblo holy men. At the same time, New Mexico was stricken by a succession of drought years during which crops failed and many people starved to death. The Pueblo people understood the cause for these calamities. Life was a partnership between the people and the spirit forces that controlled everything. Regular ceremonies, performed publicly and perfectly, vitalized the relationships between the people and the spirits. Only then would the rains fall, the crops grow, and the people prosper. The campaign by the missionaries had interfered with these necessities, and holy men began to plan resistence. In 1680, under the leadership of Popé, who was from San Juan Pueblo, the people rose up. There was no other way for them to recover the order in their lives that had for centuries kept them happy and prosperous. They killed the priests, burned the churches, drove the ranchers to Santa Fe, and then forced the

22

Spanish holed up there to flee. Although they ultimately returned, for twelve years there were no Spaniards in New Mexico.

Performing agricultural and industrial labor was not the only work for Indians in the new colonial world. There was trade as well. French, Basque, Portuguese, and other fishermen and whalers knew by the early sixteenth century that the Native people of northeastern North America were eager to acquire European metal goods. A haphazard trade developed in which Indians provided furs in exchange. By the middle of the sixteenth century a European fashion that lasted three hundred years had created a market for beaver furs, the chief raw material for the production of felt hats. By the end of the century, the French and their Native trade partners had created a system to manage what became an enormously powerful economic, political, and military alliance that supported the French empire in America and enriched many Native groups.

The Mi'kmaqs, a tribe on the Nova Scotia coast, were the first major Native trade partners, but the center of French-Indian exchange soon moved into the valley of the St. Lawrence River where the Montagnais lived. Both were hunting and gathering peoples, they spoke Algonquian languages, and they tried to control access to French goods. But the French traders recognized the value of bypassing middlemen whenever they could. Mi'kmaq prosperity was short lived because they had access to a small hinterland, but the Montagnais, who had far-flung connections as far north as James Bay, remained important into the early seventeenth century. The pattern that took shape at the beginning held, with minor modifications, until the end of the French regime in 1763.

Among Indians, trade was best understood as an exchange of gifts that verified good will among kin. Reciprocity was the essence of the rules of kinship. In the case of the fur trade, a middleman tribe like the Montagnais exchanged French goods with distant

Cree hunters who reciprocated with gifts of beaver pelts which the Montagnais then exchanged to the French for metal tools and utensils, weapons, cloth, jewelry, and a long list of other goods. This ancient Indian system of gift exchange preserved good will among foreigners, reinforced the authority of the chiefs who controlled the exchange, and moved goods from place to place. It was easy enough to incorporate the French into this system.

The reciprocal obligations that operated in a fictive kin relationship between tribes extended beyond peace and good will to military alliance. This sort of "the enemy of my friend is my enemy" thinking could result in multitribal networks of the kind that prevailed in 1609 when a combined party of Algonkin and Huron warriors met a Mohawk army on the shores of Lake Champlain. The notable feature of this episode is that Samuel de Champlain and a handful of Frenchmen armed with guns accompanied the Algonkins and Hurons and demonstrated to the Mohawks a corollary—"the friend of my enemy is my enemy." Other things figured into the enmity that pitted Mohawks and their brothers in the Iroquois Confederacy against the French, but Champlain's presence on the side of the Hurons announced a kin relationship that defined foreign relations in the Great Lakes country for many decades to come.

In 1615 Champlain, who had founded Quebec in 1608 and turned it into the center for trade, finalized an exchange relationship with the Huron Confederacy. A nation of four tribes, the Hurons lived on the shores of Georgian Bay in what is now western Ontario. They spoke an Iroquoian language, they lived in villages, grew large crops of corn, beans, and squash, and were culturally very much like their enemies to their south, the Iroquois Confederacy composed of the Mohawks, Oneidas, Onondagas, Cayugas, and Senecas. Aside from their large numbers, estimated at about thirty thousand in 1600, Huron importance to the French lay in their extensive exchange network that extended far into the interior. Between 1615 and 1649 the Hurons sent a trading fleet every year to Quebec

(to Montreal after 1642) that averaged sixty canoes laden with some 12,000 to 15,000 pounds of furs. Champlain was more than a businessman eager to maximize the fur trade; he was a devoted Christian who believed that the Indians should be converted to the faith. He insisted that the Hurons accept missionaries as a condition of the trade and that only Christian Indians could receive guns, powder, and lead for their furs. Two things resulted: some Huron men converted in order to possess guns, and the total number of guns among the Hurons was limited.

The trade made the Huron Confederacy rich and powerful. In fact, their inflated wealth and influence threatened to disrupt the Native balance of power in the Great Lakes country. The Dutch provided an offset, however, when they established in 1624 the trading post of Fort Orange at the junction of the Mohawk and Hudson rivers, the site of present Albany, New York. Well stocked with European goods, including an unlimited number of guns, the Dutch received the furs of the neighboring Mohawks and the other nations of the Iroquois Confederacy. The people of the Five Nations had long been adversaries of the Hurons and, since 1609, the French, so they welcomed the Dutch trade. The Iroquois, however, lacked a hinterland comparable to the huge one of the Hurons, and they quickly ran short of the furs, especially beaver, needed to keep the goods flowing into their country. Their solution to this problem was to raid their neighbors and loot their fur stores. The large annual Huron fur fleet was especially attractive, and by the middle of the 1640s Five Nations warriors regularly attacked it as it made its way down the Ottawa River to the St. Lawrence and Montreal.

Smallpox epidemics that first hit the eastern Great Lakes country in the 1630s caused the populations of all the nations to plummet. The Iroquois began to raid for people to replace their dead kin as well as for furs. Called "mourning wars," these invasions destroyed the Huron Confederacy. Most Hurons ended up as captive immigrants in Iroquois towns but others scattered, some east

to Montreal, others west to their trading partners, the Ottawas. But the Ottawas could not replace the Hurons as the vital Indian middleman brokers in the trade network, and well before the end of the seventeenth century the mechanics of the trade had reversed. Instead of Indians carrying furs to the French market at Montreal, French *coureurs de bois* carried manufactured goods west into Indian country.

These Frenchmen forged the fictive kin connections necessary to expand the trade, and quickly their relatives included the Algonquian-speaking Chippewas, Potawatomies, Shawnees, Miamis, the Illinois Confederacy, and many other tribes south of the Great Lakes. These tribes, residing in what came to be known as the Ohio country, became by the early eighteenth century partners in a network of reciprocal kinship obligations reaffirmed regularly by gift exchanges that bound the French and the Indians into political and military alliance. The Iroquois continued their campaign of mourning wars, ultimately sending armies west into the Mississippi Valley. But by the 1680s their juggernaut began to meet powerful resistance by western tribes armed by the French. Exhausted to the point of collapse, in 1701 the Iroquois concluded treaties of peace and neutrality that they hoped would return them to a controlling position in the Northeast.

The English began their colonial penetration of the country at Jamestown in Virginia in 1607, followed in Massachusetts by Plymouth in 1620 and Boston in 1629. English economic ambitions extended beyond trade, which was nevertheless very important, to the development of permanent agricultural settlements. In other words, the English colonial model was closer to the Spanish than the French. But unlike the Spanish, who built their empire with the labor of Hispanicized Indians, for the most part the English could find no use for the Native residents of their colonies. Locked in a sometimes violent competition for land, the English tended to think of the Indians as troublesome, often dangerous, obstacles to their plans.

The Virginia Company, a privately owned joint stock company, founded Jamestown and planned to profit from whatever commercial opportunities turned up. Hoping to find gold, the company also expected to trade with the Indians of the Chesapeake. The chiefdom political organization prevailed there. It was a dynamic institution, expanding to incorporate neighboring tribes by negotiation or conquest, and Powhatan, the paramount chief, ruled newly acquired subjects by placing them under the immediate control of his relatives. With a population estimated at fifteen thousand people, one-fourth of whom were warriors, Powhatan surely did not think of the 104 men and boys who arrived in his midst to build Jamestown as a threat. Indeed, trade began almost immediately with the English exchanging metal goods for corn and other food. Powhatan also conducted a ceremonial adoption of John Smith, a leader of the colonists, in order to establish the rules of kinship and incorporate Jamestown into his chiefdom as yet another tributary.

Whatever good will that initially existed quickly deteriorated. The Virginians refused to abide by the rules of kinship, which they almost certainly did not understand, with the result that the colony failed to fulfill its responsibilities within the chiefdom. Instead, the Virginians continued to depend on the Powhatans to provide food, and when the Indians ran short, the English colonists stole it. Believing that a policy of terrorism would keep the Powhatans off balance, tensions reached the level of open warfare by 1610. But the real revolution in relations between Virginians and Powhatans occurred later in the decade when John Rolfe introduced a strain of Caribbean tobacco that grew well in the soil of Virginia. Almost overnight, Virginia ceased to be a small, pitiful, poverty-stricken, and profitless trading colony by transforming itself into a bustling, expansionist, and aggressive society devoted to plantation agriculture.

This transformation had two impacts on the Powhatans. One was the massive influx of English people to Virginia; the other was

the expansion of the tobacco planters up the rivers and into the spaces cleared in the forest by the Indians for their villages and fields. Indians and settlers found themselves locked in deadly competition for the fields that fed the one and promised riches for the other. Bloody wars fought between 1622 and 1632 and again from 1644 to 1646, while deadly for the English almost eradicated the Powhatans. The surviving Indians accepted small reservations from Virginia and agreed to pay an annual tribute to the governor. Remarkably, two of the reservations still exist in eastern Virginia, and the Indians still give the governor venison every year.

Like indigenous Virginians, the Indians of southern New England spoke Algonquian languages and depended in large part on agriculture for their food. They also gathered wild plants, hunted animals, and fully exploited the rich sea life of the coastal region. In addition, they had stratified, hierarchical social systems and a form of chiefdom-style government that centered on the exalted status and significant power of sachems. The sachems brought together several communities that paid the chief tribute, which he then redistributed in order to cement his power. The three sachemships that were most significant in the history of early relations with the English were the Wampanoags of coastal Massachusetts, the Narragansetts in Rhode Island, and the Pequots and Mohegans of Connecticut. Together with the other groups in southern New England, their combined numbers in 1616 were about 150,000.

An epidemic of plague ravaged the New England coast between 1616 and 1618. North of Narragansett Bay, an estimated 90 percent of the people died, leaving the region virtually depopulated. The Wampanoag sachemship led by Massasoitt, for example, went from perhaps twenty-four thousand people to a mere three thousand. Two things are important about this catastrophic death toll: the English colony of Plymouth was established on a virtually empty coast, and the already volatile

politics of the sachemships were further disrupted. Massasoitt now found himself victimized by the expansionist ambitions of Miantonomi, sachem of the Narragansetts, whom the plague had spared. With a population of thirty-five thousand to forty thousand healthy people, Narragansetts were positioned to force the Wampanoags into a subordinate tributary position. Massasoitt saw Plymouth as his salvation. Plymouth was receptive to his overtures because the new settlement was weak in numbers, starving, and deeply in debt to the investors in England who financed their colony. Each side served the needs of the other in a relationship of peaceful cooperation and prosperity that lasted for many years. A trade in wampum, furs, corn, and English goods linked Plymouth via the Wampanoags to the Narragansetts and Pequots as well. Tiny Plymouth, surrounded by large and powerful sachemships, thrived.

A different branch of Puritans entered Massachusetts Bay in 1629 and founded Boston. On the day of their arrival, they outnumbered Plymouth and neither needed nor desired long-term alliances with the sachemships. In 1633/34, an epidemic of smallpox decimated the Narragansett and Pequot-Mohegan sachemships and wrecked the balance of power in southern New England. The Pequot sachem died leaving a power vacuum. The Mohegan sachem Uncas hoped to end Pequot domination of their merged sachemship. The Narragansett sachem Miantonomi saw the opportunity to oust the Pequots from the wampum business. And Massachusetts Bay planned to expand its settlements into the Connecticut River Valley, which was Pequot country. Finding justification in various Pequot provocations, soldiers from Massachusetts Bay and Mohegan and Narragansett warriors launched the Pequot War in 1636. The war ended in May 1637 with the massacre of six hundred to seven hundred Pequots at their village of Mystic, accomplished when the English set fire to the town and shot down the people as they tried to flee. For all practical purposes, this removed the Pequots from the New England political equation.

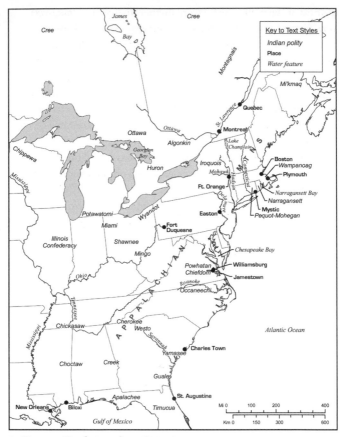

2. Eastern North America, 1600–1800.

In both New England and Virginia, the Native populations
continued to fall while the numbers of English increased. Colonial
expansion, driven by population growth, could occur only at the
expense of the Indians who, though weakened, tried desperately
to survive. But the alliances lost their value to the colonists, and
the Indians, once valued allies and trade partners, came to be seen
largely as impediments.

War began again in New England in 1675 when rumors circulated that Metacom, sachem of the Wampanoags, was planning a multitribal attack on the settlements. Called King Philip's War because the English renamed Metacom Philip, by the end of the year full-scale conflict involved the Wampanoags, Narragansetts, and many other tribes against the English and their allies, the Mohegans. Brief though it was, King Philip's War was extraordinary in its devastation. Dozens of Indian and English towns were burned, thousands of people killed (some five thousand Indians, about twenty-five hundred English), and many thousands more left homeless. About six thousand Indians survived, but most of them fled north, leaving behind only tiny isolated pockets of Native people.

Bacon's Rebellion in Virginia, also in 1676, was smaller in scale than King Philip's War, but the causes and results were much the same. Growing numbers of English colonists viewed the shrinking numbers of Indians as easily removed obstacles to the fulfillment of their economic aspirations. Led by Nathaniel Bacon, an ambitious planter who resented the power of the Virginia political establishment, a motley gang of propertyless laborers set out to exterminate the Indians. They started by attacking and looting the reservation villages belonging to the descendants of the defunct Powhatan chiefdom. Next they attacked the Occaneechis, a wealthy tribe that controlled the ford on the Roanoke River and thus the fur trade with the western Indians, and finally they attacked and burned the colonial capital at Williamsburg. Then Bacon and his rebellion died, but not before inflicting heavy casualties on Virginia's Native people.

Loot was an important motivator in both conflicts, but prisoners were also valuable when sold into slavery. Indian captives taken in New England were generally exported to England's plantation colonies farther south or in the Caribbean, the fate of the wife and child of Metacom, while those taken in Virginia were either exported or sold at home. Although Indians were never as popular as Africans to American planters, they were cheaper, and Native

women were available in larger numbers than Africans. The result was that by the middle of the seventeenth century, there was a market for captive Indians, which a burgeoning slave trade developed to supply.

The Westos were the most important early suppliers of captives. Refugee Eries who fled south from the Great Lakes to escape Iroquois armies, they established relations with Virginians and pioneered a trade that persisted in the South until the early eighteenth century. Although the Westos accepted a range of goods in exchange for captive Indians, they were most eager to receive guns. Having been victimized by gun-toting Iroquois warriors, they fully understood the military advantage guns provided. Well-armed Westos spread terror and death as they rounded up victims for their Virginia partners. Before long the Westos moved south to the head of the Savannah River in north Georgia, and when the English founded Carolina in 1670, they were ready to expand their market to include Charles Town. But in the 1680s the Westos fell victim to a factional feud within the Carolina elite over who should control the trade, and one faction, hoping to deal an economic blow to their rivals, armed the Savannahs and set them on the Westos. The Westos who survived the raids ended up in the Charles Town slave market, and they disappeared as a tribe. From this point the Indian slave trade went wild. The South became divided into two kinds of Indians—a small number of well-armed, powerful raiding groups, and a larger number of helpless victims. The Creeks, Chickasaws, and Yamasees were in the former category; the Choctaws, Guales, Timucuas, Apalachees, and countless groups whose names are lost were in the latter.

The political impact of slave raiding was profound. Survivors of victimized communities fled, and in their flight they encountered others in similar straits. Joining together because larger numbers improved the chance of survival, they relocated

and forged new polities. The Native nations of the South whose names we know formed in this period. Progenitors of the Cherokees gathered in the valleys of the southern Appalachian Mountains, the many groups who created the Creek Confederacy established their homes in what is now Georgia and Alabama, and to the southwest the groups that created the Choctaw Nation came together in Mississippi. Only the Chickasaws, located in northern Mississippi, too distant to be victimized, preserved their original identity. Having coalesced, these new nations embraced the trade as the only way to arm themselves. The Chickasaws and Creeks raided the Choctaws; Creek armies wiped out the Spanish missions in Florida. In all, perhaps fifty thousand southern Indians fell victim to the slave trade, either as casualties or as captives.

Sex largely determined the fate of the captives. Carolinians generally sent men to the sugar islands in the Caribbean because mainland colonists feared them. Women and children, on the other hand, they often kept. Slave traders mostly imported African men, and Indian women proved useful as wives. Furthermore, planters could expect Indian women to understand the agricultural demands of servitude. In 1708, fourteen hundred Indians composed about one-fourth of the slave population of Carolina.

The Indian slave trade in the South declined dramatically after 1720, largely as the result of the Yamasee War. The Yamasees, deeply involved in the slave trade, lived on the lower reaches of the Savannah River near the coast. Muskogean speakers, the Yamasees were closely related culturally to the dominant elements of the Creek Confederacy. Along with many Creek groups plus other southern nations, they organized a massive conspiracy dedicated to re-forming the trade relations with Carolina. Beginning in the spring of 1715, warriors through much of the South arose, killed the traders in their towns, destroyed the plantations extending out from Charles Town, and threatened

to obliterate the colony. The shock of the attack convinced the Carolina government that the chaos and violence of the slave trade was the chief cause of the war and that the future security of its citizens depended on bringing the slaving to an end.

The trade with southeastern Indians reverted primarily to an exchange for deer skins, which had always been significant. Statistics are incomplete and the market fluctuated, but by the mid 1740s Charles Town merchants exported more than 300,000 pounds of deer skins to England. This number had nearly tripled by the mid 1760s. Figuring an average deer skin weighed two pounds, this trade represented both a tremendous slaughter of deer and an enormous amount of labor invested by southern Indians in production for export.

For the English in Carolina, the French in Canada, and the Europeans in other colonies, trade with the Indians netted the European market beaver pelts for hats, luxury furs, and deerskins for trousers, gloves, and bookbindings. The Indian producers of these raw materials received metal goods, arms, cloth, jewelry, tobacco and alcohol, and a vast array of other things. The trade benefited both sides. For the most part, the actual exchange of goods occurred in Indian country where English and French traders were outnumbered and vulnerable. The result was that the Indians largely dictated the rules of the trade. But over time things changed. An exchange of gifts shaped by the rules of kinship evolved into a trade of goods defined by the rules of the market. The significance of this transformation can hardly be exaggerated. An exchange of gifts cemented a relationship between people, a market-based trade established a relationship between goods. Friendship based on reciprocal obligations became business conducted to maximize profits. Native people understood the implications of the transformation and became astute profit-minded traders, but they also realized that new economic ideas did not invalidate the principle of reciprocal obligation that governed relations between fictive kin. Thus while trade became fundamentally an economic

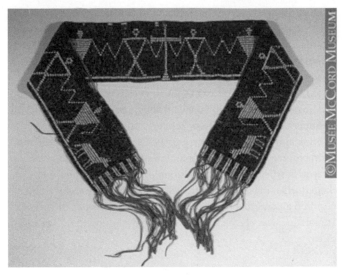

3. Wampum Belt. The Iroquois used wampum belts as diplomatic records. This one from the eighteenth century implies friendship.

relationship, reciprocity made it political. Both sides, Indian and European, readily politicized the trade. Indeed, the French, whose population in America never rose above a tiny fraction of the numbers of English, built their whole American empire on alliances with Indian tribes that had begun in trade.

In the late seventeenth century the French moved into the Mississippi River Valley and south to the Gulf of Mexico. In 1699 they established Biloxi and in 1718 New Orleans. French traders, priests, and tribal partners hoped to deny the English access to the country west of the Appalachians. The Choctaw Nation with its large population and territory rich in deer skins and agricultural produce anchored the French-Indian alliance in Louisiana. Furthermore, the Choctaws eagerly sought an ally to help them ward off Chickasaw and Creek slave raiders. The English sought to counter French encirclement with alliances of their own.

Western Indians had particular tribal interests dictated by local circumstances, and they designed policies to achieve maximum benefit from the European presence at minimal cost. All tribes embraced the same priorities—preservation of the trade, of tribal political autonomy, and of territory. Plans to achieve these goals varied with time and place but the most successful involved some variation of play-off diplomacy. Ideally positioned groups, like the Iroquois Confederacy in New York and the Creek Confederacy in Georgia and Alabama, by playing the British and French off one another, juggled imperial demands and profited in the process. As British trader James Adair complained in 1775, the Creeks "held it as an invariable maxim, that their security and welfare required a perpetual friendly intercourse with us and the French." Diplomacy was, of course, just one side of the coin. War was the other.

Between 1689 and 1763, England and France fought four wars of empire. European questions controlled the first three, and the American conflicts, while bloody, were of secondary importance. But the fourth one, called in Europe the Seven Years War and in America the French and Indian War, represented a massive struggle for dominance of the continent. Indians played a critical role in each of these wars. Most of the battles occurred in the North. In the 1690s, for example, the Iroquois and the French launched invasions of each other's territory. Each side suffered severely, but the damage to the Iroquois proved so serious that in 1701 they sued for peace and adopted their program of neutrality and play-off. Many of the conflicts in the South in the early eighteenth century, such as the Creek attacks on the Spanish missions in Florida, the Yamasee War, and French attacks on the Chickasaws, were only tangentially concerned with the wars of empire. But the turmoil in the Ohio Valley country strained relations and kept tempers hot. Delawares, Wyandots, breakaway Iroquois called Mingos, Shawnees, and others had pushed west and south from their homelands into Ohio looking for security. The Ohio River was a wide open highway between the Mississippi

River and Pennsylvania, and it quickly became apparent to both French and English that controlling it meant controlling the region.

If all other things were equal, the British could usually beat the French in a trade competition for Indian consumers. British goods tended to be higher quality, lower priced, and greater in variety and quantity. The French strength was in the quality of their diplomacy. French traders, politicians, and officers more likely learned Native languages, respected tribal ceremonies, generously gave gifts, and behaved politely. Most important, few French colonists encroached on Indian lands. These contrasting qualities sometimes made choices very difficult for tribal politicians. Although all agreed on long-term policy goals, Native leaders often disagreed on how to achieve them. One of the attractions of play-off was that a tribe did not have to make a choice.

The French responded to the English threat to their alliance in the Ohio country with military action. Armies of French and Indian troops marched in, drove back north the groups that had sought a British trade, and began to construct a string of forts in the region. One of them, Fort Duquesne at the head of the Ohio River (the site of modern Pittsburgh), gave the French effective control of Ohio. In 1755 the British sent an army under Gen. Edward Braddock to destroy Fort Duquesne, but as the army drew near, a force of Indian and French troops decimated it. Braddock's defeat is generally cited as the beginning of the final War of Empire in America.

British sea power blockaded the Canadian coast and shut down the flow of goods necessary to keep the French and Indian alliance system healthy. As frustration with the French grew in the tribal councils, British politicians moved to shatter the alliance through diplomacy. A negotiation convened at Easton, Pennsylvania, in October 1758, which brought together British officials and delegates from the Iroquois Confederation, the Shawnee, and the Delawares.

Distributing a huge quantity of presents, the British guaranteed the trade, promised to prohibit any occupation by settlers on Indian land, and asked in return that the tribes adopt a policy of neutrality. Recognizing that the French were no longer able to meet their needs, the tribes agreed, their warriors went home, the British took Fort Duquesne, and following a string of victories in 1759 the French and Indian War was over. The final peace treaty, concluded in 1763, transferred Canada to England and Louisiana to Spain. Aside from islands off the coast of Newfoundland and in the Caribbean, the French Empire in America was finished.

British victory failed to meet the expectations of the Indians. Instead of fulfilling the terms of the Treaty of Easton, British authorities shut down the trade and refused to block the flood of American settlers onto Indian lands in the upper Ohio country. By 1763 relations between the Ohio tribes and the British had become so sour that war broke out. Called Pontiac's Rebellion after an Ottawa leader, the war exploded in the western country when Native armies captured nearly all of the old French posts currently occupied by British troops. A massive British response in 1764 brought the conflict to an end but at an enormous cost, which England could not afford.

Even as Pontiac's Rebellion got under way the British government prepared to announce its plan to govern its newly won territory in America. Believing that the easiest and cheapest way to keep the peace was to accede to tribal demands for trade, autonomy, and territory, its Proclamation of 1763 drew a boundary line between the colonies and Indian country, prohibited settlement west of the Appalachians, and established a royal bureaucracy to regulate trade.

The Proclamation of 1763 put the colonies on the road to revolution and independence. Royal efforts to implement the proclamation satisfied no one. Colonists resented royal interference in their affairs, and the Indians resented the failure of government to fulfill its obligations. Agitation to modify the

boundary line intensified, and in 1768 the Iroquois ceded to the British their tenuous claims to Kentucky east of the Tennessee River. Kentucky was rich in game, and tribes on both sides of the Ohio River shared it as a common hunting ground. But word of its riches had leaked out. Daniel Boone led a party of hunters from North Carolina there in 1769. A Shawnee hunting party from Ohio captured them, confiscated their furs and guns, and warned them never to return. But they did, ultimately establishing a permanent settlement in 1775.

The Shawnees already had made preparations. By 1770 they were actively recruiting a massive intertribal alliance to defend Kentucky from encroachment. In 1774 the Shawnees nearly wiped out a party of Virginia militia who were securing British claims to the region. Virginia reinforcements arrived and drove the Shawnee warriors back across the Ohio River. More Virginians than Shawnees lay dead on the ground, but the warriors had expended all their powder and could not continue the war. In a peace treaty dictated by Virginia's Governor, Lord John Dunmore, the Shawnees surrendered their claims to Kentucky.

The story of the Ohio country and the Shawnees is the story of the west between the French and Indian War and the American Revolution. In the absence of a real peace, the struggle of the western tribes to preserve their trade, their autonomy, and their territory never ended. Indeed, from their perspective the American Revolution was simply another in the string of wars that had blazed since the late seventeenth century. The most important difference was that this time their suitors were royal officials or the agents of the rebel American states. Loving neither, the tribes acted as their best interests and circumstances dictated. If forced to choose, they generally hated and feared the settlers more than the king.

The American victory in the Revolution changed everything for the Indian nations east of the Mississippi. With the English

expelled, Indians lost the power they had commanded through play-off diplomacy. The Spanish did regain Florida, which they had ceded to Britain in 1763 in the treaty that ended the French and Indian War, but Spain posed so meager a threat that even the Creeks, who tried to use them against the United States, gained little from the effort. The most seriously defeated Native power was the Iroquois Confederacy, which split. Most Mohawks plus many Cayugas and Onandagas relocated in British Canada. The remaining people, largely Senecas and Oneidas plus a smattering of the others, stayed below the border. The Cherokees, whose country had been devastated, regrouped deeper in the mountains. The Shawnees and the other tribes in the Great Lakes and Ohio country remained both intact and in control. Nothing in their wartime experience could be interpreted as defeat. The Treaty of Paris, concluded in 1783, recognized the sovereignty of the United States and defined its limits as the Great Lakes to the north, the Mississippi River on the west, and Spanish Florida in the South. It made no mention of the Indians. Thus the United States found itself with a paper claim to an enormous country inhabited by Native nations that remained dedicated to the three goals— territory, autonomy, and trade—that had shaped their policies for decades.

Chapter 3
Indians in the East

At the end of the American Revolution, Native peoples confronted new challenges. The rapidly expanding colonies now constituted the United States, and opportunities for Indians to employ play-off diplomacy shrank. Yet the survival and growth of this infant nation depended on the relations it developed with the indigenous nations within its bounds. In its early Indian policy the United States tried to achieve peaceful expansion in the face of the Indians' determination to hold onto their homelands. Only gradually did the United States become powerful enough to risk the imposition of its will, and even then, it struggled to gain the upper hand.

In the immediate aftermath of the Revolution, the United States treated Indian tribes as conquered nations. Pent up frustration with the Proclamation of 1763 gave way to demands for reparations in the form of land. South of the Ohio River the states insisted on land cessions from the Cherokees and Creeks, and they got them, largely by unscrupulous means. In defiance, a small faction of Cherokees known as Chickamaugas joined by like-minded Creeks continued to wage war against the United States. To the north, American officials negotiated questionable treaties with representatives of several tribes in the Old Northwest to obtain land for veterans of the Continental Army. When white settlers began moving on these lands, Indians were outraged,

and an alliance of Shawnees, Miamis, Potawatomis, Ottawas, and other tribes began to coalesce into the Northwest Indian Alliance. The British, who still occupied forts in the region in violation of their treaty with the United States, encouraged their resistance. Such was the state of Indian relations when the United States ratified its Constitution in 1789.

The U.S. Constitution made almost no reference to Indians, but it gave the federal government the authority to exert control over Indian affairs, a responsibility that states had assumed since independence. Congress acquired the power "To regulate Commerce with foreign Nations, and among the several States, and with the Indian Tribes." The president assumed authority for Indian affairs largely because of two other provisions that did not specifically mention Indians. As commander in chief of the armed forces, the president was responsible for any military operations against Indians. Congress placed Indian affairs within the War Department until 1849 and then moved it to Interior, where it remains. The president also had the authority to make treaties, a right denied the states and reserved for the federal government. The United States inherited this practice from Great Britain, which had negotiated treaties with Indians to end wars, regulate trade, and acquire land. Treaties became far more than a diplomatic instrument: because only sovereign powers negotiate treaties, they implicitly recognize tribal sovereignty.

Treaties also became a means of dispossession. Since Europeans had long used treaties in their dealings with Indians, tribal leaders were well acquainted with them by the time of the American Revolution. Theoretically, Indians had much to gain by treaties, particularly in terms of trade goods and the regulation of Americans entering their territory. The process was fraught with peril, however. Equitable negotiations depended on the skill and honesty of translators, and just implementation rested with government employees. Beyond these variables lay other

difficulties rooted in Native political organizations. Despite the substantial Indian population in 1790, American Indians almost always negotiated from a position of weakness because they belonged to separate tribes that generally pursued their own particular interests. Furthermore, lines of authority were not always clear, a situation the United States exploited by enticing, bribing, cajoling, or threatening factions to sign treaties for the entire group. Because treaties were such useful devices for obtaining land from Indians reluctant to part with it, they became a cornerstone of United States Indian policy.

President George Washington's secretary of war, Henry Knox, made treaties fundamental to U.S. Indian policy. He insisted that the United States make them and keep them, and he set about creating auspicious conditions for treaty making. Faced with localized resistance south of the Ohio and a much more serious uprising to the north, Knox adopted a bifurcated strategy for getting Indians to negotiate. Generally disgusted with the frontier rabble whom he blamed for much of the trouble, Knox could not ignore the threat the Northwest Indian alliance posed, so he ordered the army into action. The Indians won substantial victories. The alliance followed its crushing defeat of Gen. Arthur St. Clair in 1791, in which more than six hundred soldiers died, with demands that the United States relinquish its claims to territory north and west of the Ohio. The United States refused, and Knox sent another army under Gen. Anthony Wayne to engage the allied tribes. Even before Wayne took command, the alliance had begun to weaken as tribes pursued independent courses, and many warriors were absent in August 1794 when Wayne attacked their encampment at Fallen Timbers in what is today northern Ohio. The outnumbered warriors retreated to a nearby British fort, only to find the doors barred. The defeat forced the Indians to negotiate, and in 1795 in the Treaty of Greenville the Indians ceded the contested land and permitted the United States to build forts in their remaining territory.

South of the Ohio, Knox adopted a more conciliatory policy. By 1794 state militias had destroyed the Chickamauga resistance, and Knox used the power granted by the Constitution to negotiate less repugnant treaties than those the states had made with the tribes before 1789. These treaties emphasized another aspect of Knox's Indian policy, the "civilization" of the Indians. In the 1790 Treaty of New York, negotiated with Creek headman Alexander McGillivray, for example, the United States promised to provide the Creeks with "useful domestic animals and implements of husbandry" so that they could be "led to a greater degree of civilization, and to become herdsmen and cultivators, instead of remaining in a state of hunters." Although the Creeks and other southern Indians had been growing corn, beans, and other vegetables for centuries before Europeans arrived, the depiction of them as hunters served Knox's purposes. First, it called into question their title to land they had not improved, and second, it permitted Knox to insist that their shift from hunter to farmer would reduce the amount of land they needed. He encouraged Indians to think of land as a commodity and to sell uncultivated "surplus" land in order to improve their farms. This, he thought, would inspire the "love of exclusive property" on which he believed civilization rested.

European culture was nothing new to American Indians. From their first encounters with Europeans, they had adopted from the newcomers goods and ideas that they found useful. Exactly what tribes or individuals embraced depended on their particular needs and circumstances. Generally, the more frequent and more intimate the contact between Indians and Europeans, the greater the appropriation of European culture was. By the 1790s, Indian enclaves along the Atlantic seaboard lived in ways that were superficially indistinguishable from their non-Indian neighbors. For the large Indian nations that held huge tracts of land in common, especially in the South, Knox wanted to accelerate the process in order to ease the alienation of land, but he did not fully comprehend the way in which most

Native people borrowed from European culture. Rather than substituting one cultural system for another, Indians tended to incorporate specific borrowings without radically changing core values.

To accomplish his goal of civilizing southern Indians, Knox depended on two categories of instructors, government officials and missionaries. The president appointed agents to live among the Cherokees, Creeks, Chickasaws, and Choctaws, and the agents employed farmers, blacksmiths, and millers to demonstrate the civilized life and provide their services to the Indians. The United States also operated trading posts that sold the tools and accouterments of civilization and permitted the Indians to run up accounts so large that they only could be paid with land cessions. With the exception of individual efforts, often short-lived, Protestant missionaries did not descend on southern Indians until after the War of 1812, but they quickly made up for lost time by establishing schools as well as churches.

The civilization that Knox envisioned had a number of components. Like his contemporaries, he thought that civilization was impossible without Christian conversion. Civilization also entailed an English education since many people believed that Native languages were limited in their ability to express complex ideas or higher numbers. Commercial agriculture formed the economic base of a civilized society, which governed itself according to republican principles, and nuclear male-headed families replaced the large, often matrilineal clans of indigenous peoples. Civilization extended beyond the structure of society to the behavior of individuals. Civilized people grew wheat, a civilized crop, not corn, a savage one. They dressed modestly in trousers, if they were men, and skirts, if they were women. They ate at regular meal times, not just when they were hungry. But most of all, they valued private property, took measures to protect it, and saw the advantage to selling it when circumstances warranted.

Southern Indians generally embraced the civilization program. The deerskin trade was in decline, so new economic opportunities proved attractive. Some acquired plows and looms and began to emulate non-Indian southerners by carving out farmsteads away from traditional towns. They expanded livestock herds and grew grain for the market. They planted cotton and acquired gins to process it for domestic use as well as export. In the first decade of the nineteenth century, the federal government constructed roads across their nations, and these thoroughfares not only brought new ideas and contact with diverse people but also sparked economic growth. Indians built secondary toll roads, operated ferries to carry travelers across the streams that crisscrossed the region, and built taverns and other facilities that catered to travelers. Not content with government trading posts, Native entrepreneurs opened their own stores, and they hired blacksmiths, millers, and other tradesmen to serve a Native clientele. They also bought African American slaves, who mostly worked in the fields cultivating crops for the market. Individual wealth in Native communities was limited to a relatively small elite class, primarily the descendants of men who had profited from eighteenth-century warfare or the deerskin trade. Some were descendants of white traders and Native women, but others were not. Not unlike the United States, these men came to dominate political as well as economic life among southern Indian nations.

These changes initially led to land acquisition by the United States. Indians became consumers, and both government trading houses and private traders extended substantial credit to them. Ultimately debts had to be paid. In 1805, for example, the Chickasaws ceded their lands north of the Tennessee River for $20,000 "for the payment of the debts due to their merchants and traders." In the first decade of the nineteenth century Cherokees, Choctaws, and Creeks also signed treaties exchanging land for cash, goods, and annual payments. These treaties often designated sums for individual headmen. In the Chickasaw treaty,

George Colbert and O'Koy received $1,000 each "at the request of the national council for services rendered their nation," and Chinubbee Mingo, "the king of the nation," got an annuity of $100 for life. Such clauses provided powerful inducements for headmen to negotiate land cessions, and the tribal domains of the large southern tribes shrank dramatically.

Almost immediately after each cession, the United States pressed for more Indian land. Driving this demand, in part, was the belief that a reduction in territory would force Indians to become yeoman farmers, but a more powerful force was the expanding population of the United States. Non-Indians encroached on tribal domains and then insisted that the federal government protect them from the Indians and secure their rights to the land they had illegally appropriated. With crocodile tears, they pointed to the deleterious effects of Indian contact with whites—a declining Indian population, drunkenness, demoralization—and advocated that Indians be pushed farther west for their own good. Consequently, United States agents residing among tribes attempted not only to transform Native cultures but also to divest Indians of their patrimony.

Pressure for land cessions prompted southern Indians to develop strategies to hold onto their homelands. Alexander McGillivray of the Creeks drew on a Mississippian tradition of chiefly power and Enlightenment ideas about republican government to try to fashion a Creek national council to conduct diplomatic relations. The Creeks' political structure, a decentralized confederacy of largely autonomous towns, posed considerable danger since the United States tended to apply to an entire tribe the terms of treaties negotiated with factions or even unauthorized individuals. McGillivray had only limited success in convincing Creeks of the wisdom of his plan, and his untimely death in 1793 deprived them of his leadership and vision. Towns were ceremonial and social as well as political units, and uniting them to make common cause was very difficult. Despite McGillivray's efforts, many Creeks

continued to identify with their towns first and the nation second, and national interest did not always resonate on the local level.

Among the Cherokees, the struggle to remain in their homeland inspired a nationalism that thwarted efforts by the United States to obtain land. Cherokee cessions negotiated in 1805 and 1806 awarded substantial payments to the Cherokee headmen who signed the treaties. When other Cherokees discovered this duplicity, they repudiated the actions and assassinated Doublehead, a chief beneficiary. Divisions among the Cherokees over land cessions prompted national leaders to explore various options—a division of the nation, citizenship in the United States, removal to the West—but most Cherokees wanted to stay together in their homeland. They temporarily deposed their chief, Black Fox, whose sympathies lay with the pro-removal faction, and moved to unify their nation in opposition to an exchange of land that would force them to the West. In the end, they retained their homeland in the East and excluded from citizenship the 2,000 who chose to move beyond the Mississippi River. Cultural change seemingly accelerated among the Cherokees, but underlying the apparent transformation was a renewed commitment to the preservation of themselves as a distinct people living on their ancestral land.

The political revitalization of the Cherokees bore some similarities to religious revitalizations occurring north of the Ohio but with different results. In 1799 a prophet arose among the Senecas who drew on a widespread Native tradition of prophecy. Disheartened by land loss and dislocation, many Senecas had turned to alcohol and their society seemed about to disintegrate. Handsome Lake, who had been a drunk, fell into a trance, and when he emerged he began to preach the revitalization of the Senecas through a combination of social change and traditional religion. Instead of the matrilineal clans, powerful women, and communal labor patterns of their traditional culture, Handsome Lake promoted male-headed nuclear families that cultivated small farms, just as

the civilization program advocated and their reduced land base required. But he also insisted on the revival of traditional religious ceremonies, a less appealing proposition for the United States but one that brought to his Longhouse religion adherents throughout the Iroquois Confederacy. Handsome Lake gave Iroquois people a way to accommodate without totally sundering their cultural moorings.

At the same time, a revitalization movement arose among the Shawnees of the Old Northwest that took a less conciliatory turn. Tenskwatawa, the Shawnee Prophet, emerged from a trance with a message of avoiding any interaction with the people who had evicted the Shawnees from much of their homeland. He urged his followers to give up drinking and to return to their traditional tools, clothes, and religion, and he denounced both the United States and Christianity. Tenskwatawa's brother Tecumseh focused on a more political message: Indians should unite in opposition to additional land cessions. Tecumseh traveled widely recruiting followers among many tribes, sometimes splitting them into factions of nativists and accommodationists. In 1811 while Tecumseh was away from Prophetstown, the seat of the alliance in western Indiana, United States forces attacked and destroyed it. Tenskwatawa survived, but his power was badly tarnished. Tecumseh forged an alliance with the British, who went to war with the United States in 1812, and helped them take American forts on the Great Lakes. In 1813 Tecumseh's warriors and British allies met United States soldiers at the Battle of the Thames. When the British withdrew, Tecumseh was killed and his warriors defeated. In the aftermath of the War of 1812, the Shawnees lost their remaining lands in the Midwest.

Tecumseh's only sympathetic audiences in the South were in the Creek Nation, where unity had proved elusive. Some Creeks, particularly among the Lower Creeks, had adopted aspects of the civilization program, and their neighbors often resented their growing reluctance to fulfill traditional obligations to town

and clan. Chiefs who profited from treaties and an association with the United States agent provoked jealousy but also dismay for failing to provide direction in these turbulent times. Tecumseh's revitalization message resonated with them, and local prophets arose to urge their followers, called "Red Sticks" in reference to their war clubs, to assert Creek sovereignty. War erupted when a party of frontiersmen attacked a group of Red Sticks returning from Spanish Florida. Red Sticks retaliated by destroying a stockade and killing its Creek and non-Indian occupants, and the Creek Nation became engulfed in a civil war. Neighboring states called out their militias for an invasion, and Creeks, Cherokees, and Choctaws joined them. In March 1814 Andrew Jackson's command overran a fort at Horseshoe Bend on the Tallapoosa River where the Red Sticks and their families had taken refuge, killed more than 800 Creeks, and took 350 captive. This battle made Jackson's reputation as an Indian fighter, and his victory there cost the Creeks not only lives but twenty million acres, much of it belonging to his allies.

In the aftermath of the Shawnee and Creek defeats, the civilization program gained renewed vigor. Much of the impetus came from missionary societies. The wave of evangelicalism that swept American Protestantism in the late eighteenth and early nineteenth centuries brought competition to the Catholic missionaries who had long labored among Indians in the Midwest. Protestant denominations, including Moravians, Quakers, and Presbyterians, established missions in Ohio and Indiana among the Shawnees, Miamis, Wyandots, and others, but warfare soon disrupted their efforts. With peace restored, missions reopened, and other denominations, including Baptists and Methodists, entered the mission field. In the South, the Moravians and Presbyterians had established missions among the Cherokees and Chickasaws before the Creek War, and once peace had been secured, Methodists, Baptists, and Congregationalists joined them. In recognition of the centrality of Christianity to the civilization program, especially in the realm of education,

Congress established the Civilization Fund in 1819 to support missions among Indians.

Missionaries saw their work as twofold—conversion and civilization—and they worked to accomplish both. Their ethnocentrism usually blinded them to Native culture, but many missionaries formed deep relationships with Indian people. Not all missionaries learned Native languages, but many did, and their translations of textbooks, hymns, and the Bible preserved Native languages and introduced a culture of literacy. Many missionaries also became advocates for the people they served. At the same time, the culturally destructive nature of Christian missions cannot be denied. Unlike most Native religions, which were capable of incorporating new beliefs and practices, Christianity was exclusive and required converts to surrender their traditional religion entirely. In some important ways, Christianity was antithetical to Native religions: it focused on individual salvation rather than community welfare, it had no formulas to heal the sick, and it had no ceremonies to make crops grow or game plentiful. Consequently, conversion rates in the early nineteenth century were very low.

Refusing to be discouraged, missionaries looked to the future, and schools were central to their work. Although many missionaries privately linked ability to ancestry, their missions rested on the assumption that Indians could learn to be civilized, and the best opportunity for achieving that goal rested with children. Limited financial resources forced them to operate day schools, but missionaries regarded residential schools as ideal because they separated children from the pernicious influence of their parents. Mission schools had strict regimens, and children divided their time between religious instruction, basic education, and manual labor. Teachers sought to instill in children order and self-discipline, which they believed Native societies lacked, and an appreciation for labor, also presumably missing. Proper gender roles were central. Boys learned to farm, split wood, build fences,

construct barns, and perform other tasks while girls focused on the domestic arts of cooking, sewing, doing laundry, and keeping house.

Among southern Indians, mission schools accelerated the cultural changes that had been taking place since the 1790s. In the first decade of the nineteenth century, the Cherokees, for example, established a national police force and made murder a crime against the nation instead of the clan of the victim. They gradually centralized political authority by empowering an executive committee to act for the nation when the council was not in session (1817), establishing electoral districts (1820) and a supreme court (1822), and enacting a republican constitution (1827). In 1828, the nation began to publish a bilingual newspaper using the symbols developed by Sequoyah. In the mid-1820s approximately 14,000 Cherokees owned 22,000 head of cattle and 46,000 hogs. They had nearly 3,000 plows, 2,500 spinning wheels, and 800 looms. Entrepreneurs operated eight cotton gins, ten sawmills, eighteen ferries, and thirty-one grist mills. Cherokees also owned more than 1,200 African American slaves. Cherokees did not share equally in this wealth. For that reason, their council passed laws protecting the private property that civilization had taught them to acquire and value.

Protecting common landholdings was an even more compelling reason to strengthen tribal governments in the period following the Creek War. Citizens of the Cherokee, Chickasaw, Choctaw, and Creek Nations did not privately own real estate. Each nation held its land in common, and although individual citizens could use the land, they could not sell it to non-citizens. Theoretically, only the nation had the right to sell its land, but exactly who had the authority to represent the nation in negotiations was not always clear. Between 1816 and 1821 the southern tribes entered into nine treaties, often fraudulently obtained, ceding millions of acres of land. The threat of further land loss provided a common cause for most citizens of the southern Indian nations, however disparate

their economic circumstances or cultural orientations. Cherokees and Creeks passed laws making land cession a capital offense, and Chickasaws prohibited citizens from accepting private tracts of land within cessions, a common way of bribing chiefs. Acquiring land from southern Indians, therefore, became extraordinarily difficult in the 1820s.

Problematic negotiations with southern Indians contributed to the federal government's disenchantment with treaty making. Knox had seen the treaties, rooted in international law, as enabling the new nation to expand with honor, but now it seemed too cumbersome as tribes became more adamant about retaining their land. When Congress refused to repudiate the practice, treaty negotiators subverted it through unscrupulous tactics. The vast majority of citizens in all the southern tribes opposed land cession, but self-serving individuals allowed the federal government to continue its acquisition of Indian land. In 1825, for example, the Creek national council rejected a proposed cession, but U.S. commissioners bribed William McIntosh, an influential chief, to sign an agreement that surrendered all Creek land in Georgia and two-thirds of what remained in Alabama. The national council invoked Creek law and authorized the execution of McIntosh and other Creeks involved in the treaty negotiations. McIntosh's death sent a powerful message to the United States as well as other Creeks: southern Indians were serious about their refusal to negotiate cessions. Fearful of an invasion by irate Georgians, however, the Creek council agreed to negotiate a new treaty, and in 1826 the Creeks exchanged the land in Georgia for a tract west of the Mississippi.

Resettling Indians in the West was not a new idea. Thomas Jefferson had cited that possibility in 1803 as a justification for the Louisiana Purchase. Jefferson envisioned removal for those Indians who chose to eschew the civilization program and pursue a more traditional lifestyle. Many Indians made that decision for themselves. Regarding the Mississippi River as a thoroughfare

rather than a boundary, Shawnees and Delawares as well as Indians from other tribes moved to the vicinity of St. Louis in the Spanish-held territory of Louisiana in the late eighteenth century. In the aftermath of Tecumseh's defeat, other Indians moved west, and in the 1820s eastern Indians began to move into Kansas. Stockbridge Indians from Massachusetts and Oneidas from New York moved into Wisconsin, and other peoples relocated as a result of settler pressure. Cherokees and Choctaws had long traveled west of the Mississippi to hunt and war, and some of them stayed. In 1810 and again in 1818–19 Cherokees moved to Arkansas where they had acquired land in exchange for eastern cessions, and in 1828 they moved still farther west into what is today Oklahoma. In 1820 the Choctaws agreed to accept a tract in the West. Despite economic and political pressure, these migrations were voluntary. Only in the 1820s did politicians begin to discuss seriously the forcible expulsion of eastern Indians.

The pressure for removal had several sources. First of all, the population of the United States grew rapidly. New states entered the union—Indiana in 1816, Mississippi in 1817, Illinois in 1818, and Alabama in 1819. Scattered Indian communities survived in the northern states as a constant reminder of recent hostilities, and in the South Choctaws, Chickasaws, and Creeks occupied fertile farmland. These states wanted the Indians out. Second, electoral reforms gave virtually all white adult men the right to vote. Campaigning, once frowned upon, became acceptable. Politicians seized upon Indian removal as an issue that garnered votes, especially in Georgia, which felt particularly aggrieved over the failure of the United States to terminate Indian title as it had promised in 1802 in exchange for the state's western lands, now Alabama and Mississippi. And finally, attitudes toward Indians had changed. The Enlightenment views that had given rise to the civilization movement gave way to romantic nationalism, a belief that each "nation" has inherent attributes that cannot be changed. In the eyes of most Americans, this meant that education and opportunity would never change the Indians' savage character: once an Indian, always an Indian.

The election of Andrew Jackson in 1828 signaled a shift in Indian policy growing out of these new circumstances. In 1830 Congress passed the Indian Removal Act, which authorized the president to negotiate the cession of remaining Indian land in the East and appropriated $500,000 for use in accomplishing this goal. The prospect of forcing Indians to the West horrified many Americans, and petitions opposing removal poured into Congress in opposition to removal, but in the end they could not stop the ethnic cleansing that took place. Disdainful of negotiating with Indians, the Jackson administration was determined to get the job done through whatever means necessary. As a result, treaty commissioners threatened and bribed chiefs, negotiated with unauthorized parties, and tried to silence all Indian opposition to removal.

Between 1830 and 1832 the United States negotiated treaties with the Choctaws, Chickasaws, Creeks, and Seminoles, which were intended to rid the East of them. These negotiations provide examples of the tactics the government used to obtain Indian land under the guise of law. The Choctaw council assembled to consider a removal treaty in 1830, and one of the women elders seated in the center between Choctaw headmen and U.S. commissioners threatened to cut the heart out of a headman who spoke in favor of removal. The council refused to agree to cede the nation's lands in Mississippi, and only post-adjournment negotiations with a rump council produced a treaty. Despite the fact that the treaty was not representative, Congress ratified it. The Chickasaws, whose nation lay just north of the Choctaws in Mississippi, signed a removal treaty in 1832 only to discover that there was no public land available west of the Mississippi on which they could locate. They ended up having to pay for the right to settle with the Choctaws, a situation that essentially suspended their own national government. The Creeks agreed to the allotment of their tribal domain to individuals, who could sell and go west or remain. Settler encroachment on their farms and attacks on their persons and property provoked Creek retaliation. Instead of offering the Indians protection, the United States removed them as a military measure.

4. Indian Removal, 1830–1850.

All of these removals were extraordinarily painful. People not only had to leave their homes and the lands where their belief systems were rooted, but they also suffered physically. The Jackson administration awarded contracts for Choctaw removal to political cronies, who maximized their profits by providing inferior and insufficient provisions. Blankets were threadbare, meat rancid, and cornmeal infested with weevils. Thousands sickened and died, generating a death toll so high that Congress ordered investigation and reform. When the army removed the Creeks, many of them in shackles as prisoners of war, they lacked adequate time to prepare for the journey and suffered terribly from exposure. Furthermore, the sweep left many Creeks stranded in Alabama, where settlers not only dispossessed most of them but also enslaved some. Among the vast majority who went west, thousands died. With no place to go, the Chickasaws retained tenuous possession of their land until the agreement was worked out with the Choctaws, and by 1840 they too had gone west.

Removal applied to Indians in the North as well as those in the South. An 1837 treaty forced one segment of Winnebagos (Ho-Chunks) from Wisconsin to Iowa, Minnesota, and South Dakota before they found refuge in Nebraska, leaving behind another part of their nation in Wisconsin. Following a series of treaties, Potawatomis from Indiana scattered into Iowa, Missouri, Wisconsin, and even Canada before most of them consolidated in the 1840s on a Kansas reservation. Having lost their tribal domain, most Miamis also left Indiana and resettled in Kansas. For Indians who managed to remain in their homelands, some lived on individually owned tracts or squatted on public lands, no longer under the governance of their tribes. Others, such as the Menominees in Wisconsin, managed to retain a common domain in their homeland, but treaties dramatically reduced the size of their holdings. Less numerous than the southern Indian nations removed in the 1830s, the stories of these peoples are not as well known, but their dispossession was as traumatic.

Violence often compelled Indians to negotiate removal treaties or abandon their ancestral lands. The Illinois militia forced Sauks to leave their village in Illinois and move across the Mississippi to Iowa in 1831. After a winter in which they nearly starved and froze to death, Black Hawk led about 1,000 of them back to their homeland. Indians from other tribes joined Black Hawk, and the frontier erupted when a company of Illinois militia attacked the desperate Indians, many of whom were women and children. Black Hawk attempted to surrender but failed, and in August 1832 hundreds of his followers died as they tried to cross the Mississippi into Iowa. When they lost their land in Iowa several years later, most of the survivors moved to Kansas.

In the South, the Seminoles resisted implementation of the removal treaty some of their headmen had signed under duress in 1832 while on a fact-finding tour of Indian Territory. When the United States sent troops in 1835 to force the Seminoles to comply, warriors executed a pro-removal headman, killed the U.S. agent, and virtually wiped out a company of soldiers. These events triggered the Second Seminole War, which resulted in the capture and deportation of small bands of Seminoles and contributed to the decision to remove forcibly the Creeks, whom the United States feared might join the Seminoles in armed resistance. In 1842 the United States, having lost 1,600 lives and having spent more than $20 million, declared peace with honor and withdrew its forces from Florida, leaving several hundred Seminoles in the Everglades.

The Cherokees decided to resist removal in the courts. Considered by non-Indians as the most "civilized" tribe, the Cherokee Nation had savvy leaders who could not quite believe that the United States would remove their people, who had embraced the civilization program, fought with the United States in the Creek War, written a republican constitution, and become a literate people. Georgia, however, demanded removal of the Cherokees and set about making the lives of Cherokees so miserable that

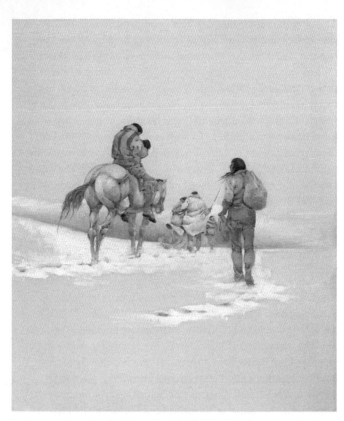

5. Jerome Tiger, *Trail of Tears* (n.d.). This twentieth-century Creek-Seminole painter captures the tragedy of his ancestors' expulsion from the Southeast.

they would agree to move west. The Georgia legislature extended state law over the Cherokees, who, like other sovereign nations, had governed themselves. Georgia laws prohibited the Cherokee government from functioning, Cherokee people from testifying against Georgians in state courts, and missionaries from residing within the nation unless they took a loyalty oath to the state. When Georgia arrested a Cherokee man who killed another

Cherokee in 1830, Principal Chief John Ross decided to challenge the extension of Georgia law in court. In *Cherokee Nation v. Georgia* (1831) the U.S. Supreme Court refused to hear the case on the grounds that the Cherokees comprised a "domestic dependent nation" that lacked standing. When the Georgia militia arrested two missionaries for their failure to take the oath, Ross had a case that the Supreme Court would hear because, as U.S. citizens, the missionaries had standing. In *Worcester v. Georgia* (1832) the court ruled in favor of Cherokee sovereignty by declaring Georgia's actions unconstitutional. The state, however, ignored the ruling, and the Supreme Court lacked the ability to enforce its decision. As Chief Ross struggled to find a solution, a disheartened faction negotiated a removal treaty contrary to the will of the vast majority of Cherokees. In the winter of 1838/39, the Cherokee Nation went west to join those who had removed first to Arkansas and then in 1828 to what is today northeastern Oklahoma.

Removal began to consolidate Indian nations far from their eastern homelands in Iowa and what would become Nebraska, Kansas, and especially Oklahoma. Indians remained in the East, but they retained so little land that they seemed to whites to be an annoyance rather than a threat. Iroquois people held tribal lands in New York and Pennsylvania, and Chippewa bands were scattered across Wisconsin, Michigan, and Minnesota. In Wisconsin, Menominees, Stockbridges, Munsees, Oneidas, and Ho-Chunks held tribal land. Pamunkeys and Mattaponis still held small reservations they had acquired in the seventeenth century, and one group of Cherokees began to put together a common landholding in western North Carolina. Catawbas retained a 630-acre reservation. Seminoles hid out on public land in Florida, while Choctaws left in Mississippi tried in vain to get title to allotments promised them in their removal treaty. Other Indians had no tribal land but maintained distinct communities. All struggled to survive both as individuals and as peoples.

Chapter 4
Indians in the West

The story of the Indians of the western United States, like that of the Indians in the East, is one of dramatic change. Although the European invasion of America carried death by disease and armed conflict, it also brought new technologies, opportunities for trade, and tantalizing avenues for power. Indigenous peoples faced the challenges of change, and the decisions they made shaped their complex histories. Of the array of novelties, few loomed larger in cultural and historical impact on Indians than the introduction of domesticated livestock, particularly in the West. Cattle, sheep, goats, and especially horses enabled western Native Americans to transform themselves.

The Spanish first brought the animals to America. By the mid-seventeenth century in the Rio Grande Valley, Pueblo men, whom the Spanish forced to serve as cowboys, had mastered the techniques of managing herds of animals. More importantly, they had learned to control and ride horses. An ancient exchange relationship between border Pueblos, such as Pecos and Taos, and plains hunters, largely Apaches, had collapsed under Spanish interference and in the absence of trade, Apache raiders took what they wanted, including horses. The Pueblo Revolt of 1680 reopened the trade, and livestock, which fleeing Spanish refugees had left behind, became an important part of the exchange. For the most part, the Apache raiders had slaughtered horses

for food, but now Pueblo men made available instruction in horsemanship. Horses had a transformative effect. They enabled their riders to travel farther and faster with more gear than they ever could on foot. Horse-mounted hunters could range widely in pursuit of game. After they killed the animals, they could carry more meat home.

The ramifications of this extraordinary revolution in mobility were first evident in New Mexico, which the Spanish reconquered in the 1690s. New laws prohibited the colonists from forcing Indians to labor and pay tribute, the Catholic priests adopted a more tolerant attitude toward Pueblo ceremonies, and the royal governors no longer treated the Indians as resources to be exploited. Interaction rested on the realization that Pueblo people and Spanish colonists needed each other in defense against horse-mounted enemy Indians. Horses had spread from the Apaches to the Utes in Colorado and then to the Comanches, who had come on foot from the Great Basin through the mountains and onto the buffalo plains during the seventeenth century. Their large numbers and a flexible and efficient political system enabled the Comanches quickly to dominate the southern plains. Despite various efforts to negotiate with the Comanches, not until 1786 did Spanish officials manage to conclude a peace with them. By this time, thoughts of renewed hostility between Spanish settlers and the Pueblo people were long forgotten.

Sheep and goats also brought important change. During the Spanish reconquest of the 1690s, some Pueblo people sought refuge in the San Juan River basin among the Navajos. Linguistically and culturally related, Navajos and Apaches had migrated south in separate bands and spread out in the high desert country of New Mexico and Arizona some time before the arrival of the Spanish. Navajos mixed agriculture into their hunting and gathering pattern of subsistence. When Pueblo refugees joined the Navajos, they brought abandoned flocks of Spanish sheep and goats. They also carried knowledge about

shearing the animals for wool and weaving it into cloth. Navajos embraced the animals and weaving, and in the process developed the only Native pastoral culture in North America.

By the middle of the eighteenth century, horses from New Mexico had fanned out through intertribal trade in three directions— northwest to the Shoshone rendezvous in southwest Wyoming, north to Mandan and Arikara on the upper Missouri, and east to the south plains tribes and French Louisiana. From the Apaches, Utes, and Comanches, horses moved to the Shoshones in the north. From there they radiated northwest to the Nez Perces and the Flatheads, who lived in the plateau country, and north to the Blackfeet, Gros Ventres, and Assiniboines of Montana and the Canadian plains. The Crows, who also lived in Montana, carried horses they got from the Shoshones east to Mandan, but so did tribes like the Cheyennes, who generally found their animals in New Mexico. The Cheyennes also took horses to the Arikara Nation. The astonishing thing about this story of the diffusion of horses throughout the plains is that it unfolded in no more than fifty years. Horses had entered a well-established exchange network that their presence expanded.

Horses, for example, came to link Indians on the Northwest coast with the interior Plateau peoples. Northwestern Indians lived on a relatively narrow coastal plain between the mountains to the east and the Pacific Ocean to the west in villages composed of large houses built with cedar boards. Located at the mouths of streams, they were well situated to exploit both the riverine salmon fishery and the mammals and fish of the sea.

Some tribes, such as the Makah at the far northwest tip of Washington, were accomplished whalers. Highly trained and ritually prepared through fasting, prayer, and purification, they paddled among the animals in canoes carved from huge cedar trees, harpooned and killed them, and towed them to shore for butchering. Usually able to kill more whales than they could use,

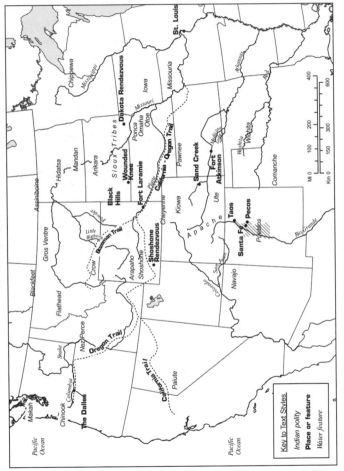

6. The Diffusion of Horses.

the Makahs exchanged preserved meat and oil with tribes that did not hunt whales in an intertribal exchange network that moved food, raw materials, carved wood products, enslaved captives, and other goods up and down the coast.

Under the control of the Chinooks, a group that lived at the mouth of the Columbia River, commerce connected the people of the coast with tribes as far east as the Missouri River. All streams that flowed into the Pacific were trade routes, but no river equaled the Columbia. For centuries before Europeans entered the scene, the Chinooks carried coastal goods to the Wishram village located at the rapids known as The Dalles, where they traded for the products of the interior. In the late eighteenth century, a maritime trade with English and American shippers introduced to the coastal tribes a wide variety of manufactured goods in exchange for sea otter pelts. The Chinooks mixed these goods into their regular stock and thus controlled the movement of such items into the hands of people who had no exchange relations with non-Indians. As horses arrived from the East and became exchange goods at the Shoshone rendezvous, they fell into the hands of the Nez Perce living in the Washington-Oregon-Idaho border country, who used them to import buffalo robes and other plains products that they traded at The Dalles. Plains and coastal products met there, attracted thousands of people, and changed the material cultures of dozens of tribes.

Even more profound change came to the plains where, when horses arrived in the seventeenth century, two kinds of people lived. One group was the pedestrian hunters and gatherers, such as the Apaches. Small in number and widely scattered, they made a precarious living hunting buffalo and other animals on foot. The other group, much larger in number, was riverine agriculturalists. Mostly located on the Missouri River system, the Witchitas, Pawnees, Otoes, Missourias, Iowas, Omahas, Poncas, and others lived in Kansas and Nebraska while the Arikaras, Hidatsas, and Mandans lived in the Dakotas. Building villages on bluffs overlooking river valleys, they grew corn, beans, and squash in

the floodplain. The farmers hunted buffalo and other animals as well, but long before the arrival of Europeans they had developed exchange relations with the hunters. Indeed, the Arikara and Mandan villages became trade centers as important as The Dalles.

In the late seventeenth and early eighteenth centuries, many groups migrated to the plains. Some, like the Comanches, came from the west but most, like the Cheyennes and the many tribes of the Sioux, came from the east. Like all immigrants, they came in search of better opportunities, but they also often made the move as refugees fleeing forces at home they could not resist. The story of the Sioux, the best known group of outsiders who made the plains their home, is a bit of both.

The Sioux are a large nation composed of seven tribes. Their homeland was in the forested and swampy country of northern Minnesota and Wisconsin. They hunted moose, elk, and deer for food, beaver for fur, and gathered plants, most importantly wild rice, which was abundant in the many lakes of the region. At the far western end of the French trade network, the Sioux depended on Chippewa middlemen for their market. But the Chippewa, armed with guns by their French trade partners, worked to expel the Sioux from their beaver grounds. The Sioux gradually gave way, pulling back to the west in search of new beaver streams and out of the way of the Chippewa. The Tetons, the westernmost tribe of the Sioux, led the way and ultimately reached the prairie country east of the Missouri River. There they found buffalo. The eastern Sioux tribes met the Tetons at the Dakota rendezvous in southeastern South Dakota where they exchanged buffalo robes and meat for wild rice and guns. Carried by Teton traders, guns ended up at the Arikara market. In a similarly convoluted fashion, French guns passed through many hands to the Cree who carried them from the Canadian plains to the Mandan market. By the middle of the eighteenth century horses and guns, the defining artifacts of plains Indian culture, met at Mandan and Arikara and became central to the trade.

7. Indians in the West, 1680–1890.

Commerce made the Mandans and Arikaras both rich and vulnerable. Native enemies always knew the locations of their villages, but their most deadly foe was disease. During the eighteenth and nineteenth centuries, an epidemic struck the plains every five to seven years. None equaled the devastation of the smallpox that traveled by the same trade routes that spread horses and guns and raged from 1779 to 1783. Smallpox, a highly communicable crowd-disease, spread, and the villagers caught it by the thousands. The Arikaras, who had lived in thirty-two towns, coalesced in just two. The death toll among the Mandans and Hidatsas was the same. While the tolls were probably lower among the mobile horse-mounted hunters, smallpox, did not spare even them. The Assiniboines spread it north from Mandans to Crees, who carried it to the shores of Hudson Bay. Crow traders carried it west to the Flatheads in western Montana. The Shoshones took smallpox to the Nez Perce, who passed it on to the Columbia River tribes, from whence it made its way to the Pacific and up the coast to Alaska. Blackfeet warriors encountered smallpox in a camp of enemy Shoshones in Idaho and carried it north into Saskatchewan. The death tolls were 90 percent among some tribes, "only" 60 percent or so in others, in some groups even less, but the anguish and fear was universal.

Smallpox was only one source of demographic change. Increasing numbers of mounted Indians moved out on the plains to hunt buffalo and encountered one another in their search. To manage the problems of sharing, the tribes staked out areas and claimed them as their own. Hunters following buffalo rarely respected these claims, and conflict intensified. Tribes raided each other for horses, necessary because many horses died during the winter and Indians without horses could not hunt. Tribes also invaded the countries claimed by their neighbors and tried, sometimes successfully, to displace them. No group was better at this than the Teton Sioux. Their numbers constantly replenished with relatives from the East, they took advantage of the near eradication of the Arikaras to burst across the Missouri River and fan out into the

country north of the Platte River. Some groups, such as the vastly outnumbered Cheyennes, concluded an alliance with the Tetons. Some, such as the Crows, retreated. Others, like the Pawnees south of the Platte in Nebraska, remained close to home.

Conflict led tribes to heap praise on their warriors, calling them saviors and heroes and rewarding them with status and prestige. These accolades encouraged boys to work hard, hone their skills, be ambitious, and grow up eager to serve their communities through raiding and warfare. The warrior culture of the plains tribes also became intensely religious. There was nothing new about recognizing, respecting, and seeking to benefit from the spirit forces that influenced all aspects of life. But as violent conflict escalated in both vital importance and deadly danger, ritual, fasting, and prayer took on new significance, the ceremonial cycle became more elaborate and complicated, and holy people known to possess powerful medicine assumed added responsibilities.

The competition for buffalo range paralleled an equally intense, if shorter lived, struggle to control access to beaver. This was particularly true on the northern plains. The French beaver trade that had begun in the East in the early seventeenth century had spread west through the Great Lakes country, into the Canadian forests and prairies of Manitoba and Saskatchewan, and south to the headwaters of the Mississippi River and the village trade centers on the Missouri. By the end of the eighteenth century, northern plains Indians were fully linked through the village trade networks at Mandan and Arikara to the European fur trade economy.

In 1803 the United States acquired the Louisiana Territory from France, and President Thomas Jefferson sent Meriwether Lewis and William Clark to explore the country all the way to Pacific. One of their primary purposes was to open trade with the Indian tribes. St. Louis, part of the purchase and already involved in the trade with the tribes, quickly became the commercial center

linking the tribes of the Missouri River to the United States. In 1822 the American Fur Company, headquartered there, entered the Missouri River trade with money, organization, and manpower. Establishing fortress-like trading posts that dealt directly with Native hunters and trappers, the company circumvented the riverine village middlemen and sent brigades of non-Indian trappers into the mountains to compete directly with Indian hunters.

The resulting loss of interaction between tribes did not cause the cutthroat competition and conflict that marked plains Indian life in the nineteenth century, but it probably exacerbated it. The trade fairs at Mandan and Arikara, and the Shoshone and Dakota rendezvous, had brought people from different tribes together in a mutually beneficial exchange relationship that had far-reaching social, political, economic, and cultural ramifications. Now these gatherings declined.

American Fur Company competition did more than divert trade from Indian villages. Interloping fur company trappers combed the Rocky Mountains for beavers, thereby denying Indian trappers access to their most valuable trade commodity and effectively exterminating the animals. The beaver hunt had provided Indians with the means to acquire manufactured goods without compromising their subsistence economy. Plains Indians hunted buffalo to eat; they hunted beaver to sell. The loss of the beaver forced the Indians to a trade in buffalo hides. Killing to trade what they killed to eat did away with their economic safety net. By the 1830s this transition was complete, and buffalo robes had become the staple of plains trade.

Some buffalo robes had always had value. Beautifully tanned and decorated by talented and artistic Native women, robes had found both Native and non-Indian buyers at Mandan, Arikara, and beyond. They were expensive luxury goods, however, with a limited market. Undecorated hides, heavy and hard to transport, had little value until industrialization in New England created a

virtually insatiable market for them. Buffalo hides, thicker and stronger than cowhides, were admirably suited for drive belts to run machines. This meant that the trickle of hides that traders had floated down the Missouri to St. Louis quickly became a deluge. Between 1825 and 1830, 785,000 buffalo hides passed through St. Louis bound for New Orleans and shipment onto the world market. This kill rate, when added to the estimated 500,000 buffalo plains Indians needed per year for subsistence, could be sustained only if nothing else happened, but it did.

By the early nineteenth century an estimated 2.5 million wild and domesticated horses competed with buffalo for grazing land. During the 1850s non-Indian emigrants drove an estimated one million cattle and sheep across the plains to the Pacific coast. They not only ate the grass that fed buffalo, they brought novel diseases that caused the animals to sicken and die. And periodic droughts killed more grass. The result was a spiraling decline in the numbers of buffalo on the plains. While it is true that after the U.S. Civil War professional non-Indian hide hunters killed the buffalo to near extinction, at the pace they were going Indian hide-hunters likely would have done the same. It would simply have taken them longer to do it.

The trade in buffalo hides impacted the Native people of the plains in important ways. In addition to intensifying tribal competition for access to the herds and increasing horse raiding and intertribal warfare, the hunt significantly affected internal social and economic order. In the days before horses, hunting buffalo was a community affair. Men, women, and children joined forces to drive the animals into pounds or over cliffs; they worked together skinning and butchering the carcasses, and they shared meat and hides. When horses arrived, hunting became an exclusively male activity, and the animals killed were the property of each individual hunter. Good hunters became rich and famous, poor hunters became dependent. Processing the extra hides demanded more workers, so successful hunters married more

wives, raided for captives to enslave, or purchased slaves on the market. The Comanches on the south plains, for example, were distant from the trade in buffalo hides, but they excelled at raiding for horses and captives, which Cheyenne middlemen took north for sale. One way or another, wealthy northern hunters increased their labor force, their hide production, and their wealth.

In the midst of this transformation, between 1846 and 1848 the United States and Mexico fought a war that resulted in the American acquisition of the Southwest. Also in 1848 construction workers discovered gold in California, now an American possession. When news of the gold reached the East, it set off the fabled California Gold Rush. Between 1840 and 1860 an estimated 300,000 people followed the Platte River west across the plains. At least two-thirds of them went to California; the rest headed for Oregon and Utah.

The people who arrived in California found a place with a history unlike anywhere in the West. With a population estimated at 310,000 in 1769, Native California had been the most densely populated region in Native North America and the most linguistically diverse, with as many as eighty different languages. Hunters and gatherers, they subsisted largely on small game, sea mammals and shellfish, and acorns, which they ground into flour and baked into bread. Tribes tended to be very small, rarely larger than 500 people, and political and social organization tended to be hierarchical. The Spanish asserted their claim to California in the 1760s by sending priests and soldiers to construct a string of missions from San Diego to San Francisco. Depending on intimidation to control the Indians they hoped to convert, the priests looked to the soldiers to bring them candidates and keep order. But the soldiers often abused the Indians, stole their food, and raped their women. At the missions, Indians constructed buildings, grew crops, cared for livestock, and manufactured a variety of goods for export. All this labor, combined with a poor diet, bad water, crowded and filthy living conditions, rampant

disease, and abusive treatment, quickly depleted the Indian population.

Mexico, which had gained its independence from Spain in 1821, closed the missions in 1834 and distributed mission property to well-connected Mexican families. Secularization rendered mission Indians homeless, forced them either into the towns as laborers or into the country to work on the ranches, and moved the region of contact from the coast into the central valley. Mexican impresarios used peonage, or debt slavery, to exploit their labor, while squads of irregular Mexican troops scoured the country in search of Indians to impress into servitude. The United States acquired California in 1848, and when miners arrived to extract gold, they adopted the exploitive labor system of their predecessors. The impact on Indian people was devastating: by 1865 the total Native population of California had dropped to just thirty thousand.

Less obvious, the trek across the plains of people bound for California took a toll on plains people as well. The livestock that migrants drove through Indian country were destructive, and people cut trees for camp fires. This migration created a line of devastation that, by some reports, was fifty miles across, a swath too wide for buffalo to cross. Rarely attacking the wagon trains and killing no more than a few hundred migrants, plains Indian warriors did stop the travelers to complain about the damage and demand payment for the right to cross their lands. When they got to their destinations the migrants, terrified of the Indians and outraged by their behavior, demanded that the government take steps.

The United States had been dealing with Indians since its inception in 1789, but policies designed to gain territory made little sense in the early nineteenth-century West. Policy there promoted trade and peace. Tribes long enriched by their middleman role in trade resented efforts of traders to bypass them, and enemies did not want each other to have the tools and weapons traders supplied. Harassment, thievery, and the

odd murder broke into open warfare in 1823 when the Arikaras attacked a party of ninety traders and boatmen under command of a prominent St. Louis trader. The survivors fled back to St. Louis and a retaliatory force of about one thousand men, mostly U.S. infantry plus 250 Sioux warriors and a gang of frontier toughs, marched north to teach the Arikaras a lesson. The battle, marked by an ineffectual artillery bombardment, ended in a negotiated cease-fire. The Arikaras dispersed, the toughs burned the two Arikara villages, and the Missouri River was opened to trade. Two years later, troops supervised treaty negotiations with sixteen bands along the river, establishing the policy of peace and trade that prevailed in the Missouri Valley for the next two decades. After 1848 the policy proved incapable of adapting to the new reality that the plains, once the ends of the earth, were now in the center of a continental power.

The new U.S. Indian policy for the West unfolded in a series of steps. First, the peace and trade program extended federal influence throughout the plains. In 1851 and 1853 federal negotiators hosted two huge treaty conferences, at Fort Laramie in southeast Wyoming with the north plains tribes and at Fort Atkinson on the Arkansas River with the south plains tribes. Believing that peace between tribes helped ensure the safety of the thousands of Americans traveling across the plains, the treaties featured commitments to end intertribal hostilities. They also required the tribes to permit military posts in their lands and the roads across them. The tribes had to provide restitution for any depredations committed upon travelers using the roads, and in return, the United States agreed to punish any of its citizens who committed depredations upon the Indians. In the Fort Atkinson treaty, the Comanches, Kiowas, and Apaches promised to stop raiding Mexico. At Fort Laramie the Sioux, Cheyennes, Arapahoes, Crows, Assiniboines, Gros Ventres, Mandans, and Arikaras pledged to identify their respective territories on a map so that the United States could have a clearer idea of who lived where. In a futile effort to impose an American-style political order over the band-level hunting societies of the

north plains, the Fort Laramie treaty also insisted that the tribes each name a head chief who would in future conduct all "national business" with the United States. Each treaty promised money and goods to be paid each year as an annuity to compensate the tribes for the roads and for the damage done to the country by the travelers. But annuities played a coercive role as well: tribes judged in violation of the treaties had their annuities withheld.

The second step was a plan to accommodate the village agriculturalists who lived in the river valleys of eastern Nebraska and Kansas. Congress, thinking about a transcontinental railway, considered organizing Kansas and Nebraska into territories with substantial populations of non-Indian residents, a potential crisis that the commissioner of Indian affairs sought to avoid with a reservation policy. By reducing the Indians' land base, large amounts of land could be released for settlement. Reserving some land for Indians and providing proceeds from their cession as investment capital theoretically would encourage Indians to become civilized farmers. Between 1854 and 1857 fourteen treaties established reservations in the watershed of the Missouri River.

Thinking about the need to protect Indian people from rapacious non-Indian settlers, the United States tried to establish the reservation program in Texas, but Texans would tolerate no Indians in their midst. Because the state retained ownership of its public lands, the United States could do nothing to put the policy in place. In California federal officials negotiated several treaties with Native leaders that would have set aside lands for reservations, but the state's senators, arguing that the proposed reservations were too large and the land was too valuable, prevented the Senate from ratifying them. Conflict over land rights between Indians and settlers in the Northwest was a problem that the Washington territorial governor hoped to solve with several reservation treaties. By the time of the Civil War, reservations had become a central theme of U.S. Indian policy.

Treaties and reservations could neither anticipate nor resolve all the problems caused by the collision of an expansionist United States pressing onto the lands and interfering with the lives of western Indians. Between the mid-1850s and the late-1870s violent conflict was more or less constant. The wars began in 1854 when a young army lieutenant attempted to bully a band of Brule Sioux into compensating a migrating Mormon for a cow they had slaughtered. Hot heads and inexperience led to gunfire; all the soldiers and several Indians were killed. Revenge killings by both sides followed. A decade later, a politically ambitious preacher led a militia of unemployed Colorado miners against a band of Cheyennes led by Black Kettle camped at Sand Creek. The wanton brutality of the attack and the postmortem mutilation of the women victims outraged the plains tribes. Congress held hearings and expressed its chagrin, but no one was punished. At about the same time, the government opened a fortified road, the Bozeman Trail, through the Powder River country, site of some of the best buffalo range north of the Platte River, to serve mining interests in Montana. Teton Sioux warriors attacked the forts and disrupted traffic on the road. Another young and inexperienced army lieutenant, intent on teaching the warriors a lesson, led his troop into an ambush and was wiped out. On the south plains, the story was different only in that the U.S. Army played a minor role. Comanches and Kiowas battled the Texas Rangers, a state militia force renowned for its brutality.

Both theaters demonstrated the same fact: the army was not effective against the Indians. Plains warriors were skilled guerilla fighters, Indian women could pack up and move their villages at a moment's notice, and keeping troops in the field and supplied was both difficult and expensive. One accountant figured that each Indian killed by the army cost the United States $1 million. High costs, military stalemate, and the bad press the conflicts generated in the East pushed the government toward negotiations. Congress appointed a peace commission composed of military officers and prominent civilians to travel into the plains country, conduct talks

with the tribes, conclude peace, and introduce the reservation policy to the plains hunters. In 1867 the commission met with the Comanches, Kiowas, plains Apaches, southern Cheyennes, and Arapahoes on Medicine Lodge Creek in Kansas. The next year it hosted the leaders of several bands of western Sioux, the Crows, and the northern Cheyennes and Arapahoes at Fort Laramie. These treaties declared peace, created reservations, promised annuities, and stressed civilization through schools, seeds and implements for farming, and a voluntary allotment program by which individuals could lay claim to 320 acres on which to develop a family farm. Red Cloud, an important Oglala Teton war leader, refused to sign the Fort Laramie document until the United States closed the Bozeman Trail and abandoned the forts built to protect it. His victory on this point was hailed as an important achievement and cemented Red Cloud's prominence as a Sioux leader.

Peace was elusive on the south plains. In the aftermath of the Treaty of Medicine Lodge Creek, bands of all the tribes involved set up their camps on their reservations. One group of southern Cheyennes settled for the winter on the Washita River. But young men eager for booty and status periodically left the reservation to raid settlements in Kansas. One such party, returning home in November 1868, left a trail that Gen. George Armstrong Custer and his cavalry followed. Their surprise attack killed many Cheyennes, including Black Kettle, who had survived the massacre at Sand Creek only four years before, and ignited a conflict that lasted another six years and that spread to the Kiowas and Comanches as well.

The United States threatened the peace established at Fort Laramie in 1874 when General Custer led a mixed expedition of army and civilians into the Black Hills to investigate rumors of gold within the boundaries of the Sioux reservation. When the miners in the company found gold and spread the news to the outside world, a gold rush ensued. The U.S. government refused to police the boundary of the reservation and to remove the

miners who encroached on Sioux lands. Instead, federal officials approached Sioux leaders with offers to buy the Black Hills. Rebuffed, the government then ordered all Sioux bands, many of which had left the reservation to hunt, to assemble on the reservation by January 1, 1876, and declared those who refused hostile enemies of the United States. In the spring, troops began looking for the bands of "hostile" Sioux. One camp of Teton Sioux and Cheyennes under the leadership of Sitting Bull, estimated at ten thousand, was located on the banks of the Little Bighorn River in Montana. Late in June General Custer led his cavalry to the camp, where the warriors under Crazy Horse, Hump, and Two Moon decisively defeated them. In reprisal the army scoured the country and forced most of the people still off the reservation to go there. Sitting Bull led a small number of followers to refuge in Canada, but starvation forced them to surrender in 1881.

The irony of all this bloodshed was that it occurred during the period of the Peace Policy of President Ulysses S. Grant. In place from 1869 to roughly 1876, the policy's central idea was that the reservations would be administered by church groups. Agents appointed by mission boards would presumably be godly, honest, and dedicated to doing good for the Indians. The Peace Policy, however, had a counterpoint: the policy was peaceful only for those tribes that followed orders, remained within the boundaries of their reservations, and enthusiastically embraced the regimen of culture change the missionaries/agents proclaimed.

Part of the failure of the Peace Policy can be chalked up to the almost uniform incompetence of the agents. Chosen for their piety and zeal, few had experience with Indians or knew anything about them. With little understanding of or interest in Indian histories or cultures, the agents tended to be insulting, petty, impatient, and unreasonable in their relations with their charges. Neither liking the Indians nor liked by them, the churchmen rarely lasted long enough in their agencies to learn anything useful. Nevertheless, by the early 1880s virtually all the plains Indians lived on

reservations, driven there by the extermination of the buffalo and starvation.

Hunger followed many to their reservations where they depended on the government to distribute rations. But the rations were not dependable. Congressional appropriations were inconsistent, dishonest agents stole and sold the food, and sometimes officials withheld available rations to control the Indians. Agents at the Sioux reservations in South Dakota reduced the rations in 1889, and the people were in danger of starvation. Hope existed, however, in the form of prophecy. Wovoka, a Paiute holy man from Nevada, had dreamed a ceremony, the Ghost Dance, which induced visions in which participants reunited with dead relatives, the buffalo returned, and non-Indians disappeared. The Ghost Dance swept through the Sioux reservations in 1890, large numbers of people danced, and neighboring non-Indians were terrified. The panicked agent at Pine Ridge called in the army. The chiefs at Pine Ridge, fearful that something terrible might happen, called into the agency people who were dancing. One band of about 350 led by Big Foot camped at Wounded Knee Creek on their way to Pine Ridge when the soldiers found them. On the morning of December 29, during a search of the Indians for weapons, someone fired a shot. This led to a barrage of fire from the army's cannon, and as many as three hundred of the Indians were killed. The massacre at Wounded Knee ended the brief but spectacular history of the horse-mounted, buffalo-hunting Indians of the plains.

Chapter 5
Assimilation and allotment

United States Indian affairs contained many contradictions, none quite as apparent as the seemingly antithetical policies of separating Indians on reservations while assimilating them into American society. Separation presumably provided Indians with an opportunity to acquire the skills they needed to assimilate, but the process of preparing Indians for assimilation on reservations seemed excruciatingly slow. By the late nineteenth century, many people had concluded that the time had come to withdraw the special status of Indians as sovereign peoples and incorporate them as individuals into American society. The United States embarked on an effort to educate Indian children for their integration into the mainstream and adopted policies to force Native peoples to abandon their own cultural traditions. Reformers embraced assimilation because it promised the dissolution of tribes, regarded as vestiges of savagery and primitivism in the modern world. The demise of tribes meant the end of tribally held land, an objective capitalists could support, and the elimination of government expenditures for Indians, an attractive prospect for politicians.

Before the Civil War, missionary societies operated schools among a number of Indian tribes, especially in the East and Midwest, and a few tribes supported their own schools. Following the war, Indian education became a feature of U.S. policy, and treaties

provided for the establishment of schools. In 1870 Congress appropriated $100,000 for Indian education, an amount that increased over twenty times in the next two decades but never came close to meeting the needs. Given the paucity of resources and the difficulty of hiring teachers, the Office of Indian Affairs (OIA) often turned to mission societies to run schools. Imbued with religious zeal, missionaries displayed little cultural sensitivity. They conducted classes in English and discouraged any display of traditional culture. Francis La Flesche, an Omaha enrolled in a Presbyterian school in Nebraska in the1860s, recalled that the school master had the boys recite their lesson for visitors. The first question was, "Who discovered America?" The correct answer was not "Indians." Children found ways to resist the indoctrination. When the visitors asked students to sing an Indian song, one boy broke out in the Omaha victory song. Others joined in. "We felt, as we sang," La Flesche remembered, "the patriotic thrill of a victorious people who had vanquished their enemies." Although they had requested the performance, the visitors snapped, "That's savage, that's savage! They must be taught music."

The names of Indian students posed a problem for their teachers. Most Native people did not have given names and surnames, and a person's name might change over his or her lifetime. Missionaries, teachers, and government officials found Indian names unpronounceable and translations nonsensical. Therefore, they often named children after famous Americans. La Flesche, whose name came from his French grandfather, attended school with other Omaha children whom missionaries had named Isaac and Abraham as well as George Washington, William T. Sherman, and Ulysses S. Grant. By the 1890s United States superintendents at some agencies had realized that the use of such names "caused the Indians to become the butt of many a vulgar joke," and they abandoned the practice in favor of English given names and Indian surnames, usually in translation. Even then, difficulties arose. When an Indian policeman enrolled a little Apache boy in school in Arizona, the superintendent asked his name. "Des-to-dah," replied

the policeman, so the superintendent named the child Max Des-to-dah. Only later did he learn that Des-to-dah meant "I don't know."

In the 1890s the federal government began to secularize Indian schools. When the OIA appointed its own employee as superintendent of the Cherokee Training School in North Carolina, the Quaker missionary who had headed the school refused to surrender it. He kept the keys, stole the manure, and removed several older students to a nearby town where he hired them out. The incident exacerbated factionalism within the Cherokee community, but ultimately the Indian Office won, and the Cherokee school became the administrative model for federal control of reservation boarding schools.

An experiment launched by Lt. Richard Henry Pratt in 1875 shaped off-reservation schools. Pratt had charge of Cheyenne, Comanche, and Kiowa warriors imprisoned at Fort Marion in St. Augustine, Florida. He established a system of military discipline and classroom instruction for these adult men, and the results astonished both the lieutenant and Indian reformers. The men enjoyed marching and learning, and they were adept at both. In 1878 Pratt arranged for seventeen of them to enroll at Hampton Institute, a Virginia school established after the Civil War for African American freedmen. The Indians excelled, and the regimen developed by Pratt seemed to hold out far greater promise for the civilization of Indians than reservation schools. Consequently, Pratt persuaded the government to open an Indian boarding school at an old army barracks in Carlisle, Pennsylvania. Carlisle Indian School became the model for Indian education, and by 1901 twenty-four other non-reservation schools had opened throughout the nation. Eighty-eight reservation boarding schools, serving from thirty to two hundred students each, and a host of day schools supplemented them.

All of these schools embraced Pratt's educational philosophy: "Kill the Indian, save the man." Removing children from their

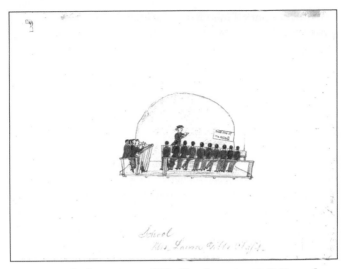

8. Zotum, *School Mrs. Laura Gibbs Class* (ca. 1875–1878). Drawn by an imprisoned warrior, this schoolroom at Fort Marion with its neat rows and uniformed students became the model for Indian boarding schools.

families and communities was a first step. Agents sometimes used heavy-handed tactics, including denial of rations, to force parents to send their children to boarding schools. But many parents believed education offered their children a brighter future, and recruiters enticed prospective students with candy, the promise of a train ride, and the prospect of adventure.

The transformation began as soon as children arrived. The Yankton Sioux writer Zitkala-Ša (Gertrude Bonin) remembered her reaction to the appearance of the students she encountered upon her arrival at Carlisle. The girls' fitted bodices struck her as immodest, and, in Sioux culture, their haircuts denoted mourning or cowardice. She hid to avoid a similar fate, but the teachers found her: "I cried aloud, shaking my head all the while until I felt the cold blades of the scissors against my neck, and

heard them gnaw off one of my thick braids. Then I lost my spirit." Boarding schools completed the makeover by requiring girls to wear Victorian dresses and boys military uniforms, forcing children to adopt English names, and forbidding students to speak their Native languages. Sioux student Luther Standing Bear remembered how startled he was when told he had to sleep in a nightshirt that he thought looked "just like a woman's dress!"

In 1901 the U.S. superintendent of Indian schools developed a standard curriculum based on her visits to institutions both on and off reservations. She was interested primarily in equipping young Indians for citizenship and assimilation, and she thought that schools should teach academic lessons largely through manual training. Every school day, students devoted three hours each to academic subjects and manual training, but the lines between the two often blurred. Students, she believed, learned to speak English by doing chores. The regimen applied even to very small children: following the instructions of their teachers, first-year girls cooked small bits of food for their dolls. Older students took English dictation on gender-appropriate subjects such as cooking, laundry, gardening, and woodworking, and the books in which they wrote these dictations became their textbooks, supplemented occasionally by more conventional books. Boys learned arithmetic by fictitiously purchasing livestock, stringing fence wire, or building a table; girls learned by hypothetically selling pottery, measuring fabric, or buying groceries. History became, first of all, a lesson about racial progress. Students began by sharing their tribes' histories, couched in terms of the "upward struggles of their people." Teachers unfavorably compared the Indian past to contemporary Euro-American culture and extolled, in particular, the superiority of agriculture to hunting. Then they turned to the history of the United States. Lessons deemphasized war and promoted a "spirit of love and brotherhood...toward the white people." Students learned about how the government worked and celebrated the

birthdays of famous men—Washington, Lincoln, and Henry Wadsworth Longfellow, the author of "Hiawatha," a poem they memorized. The purpose, according to the superintendent of Indian education, was "preparation for citizenship."

Manual training was central to the curriculum because it taught the children order and discipline in contrast to a "wild, free, and easy life," as the OIA characterized their Native lifestyles. Furthermore, skills led to jobs and to assimilation, and manual training taught new gender roles that differed from those in most Native communities where men were presumed to do little work. All boys learned to farm and care for livestock since policy makers expected them to end up cultivating individual allotments of tribal lands. Boys also studied harness making, carpentry, masonry, blacksmithing, upholstering, tailoring, and other trades. Girls had fewer opportunities: their sex, the superintendent concluded, made them "handicapped in the eternal struggle of life." Nevertheless, they had to learn to be good housewives by mastering cooking on a stove, doing laundry, sewing, and performing other chores. Training as cooks and nurses offered some possibility of employment, but teachers expected most girls to return to their communities, marry educated men, and become role models for other Native women.

Non-reservation schools adopted the outing system developed by Pratt at Carlisle. The schools placed students for a period of time with non-Indian families, usually on farms, where they could learn from practice how to operate a farm and manage a household. Many students attended public schools, a further step toward assimilation. Students earned some compensation, which school officials placed in accounts for them to teach them "the value of labor and money." Most important, the superintendent emphasized, the outing system imparted "the lesson of Americanism."

A few students secured non-agricultural positions through the outing system. Luther Standing Bear and Clarence Three Stars,

Sioux students at Carlisle, worked for Wanamaker's Department Store in Philadelphia and boarded at a school for the orphans of soldiers. The experience was a mixed one. Luther liked his work as a clerk and bookkeeper, and he took particular pleasure in countering the stereotype that "an Indian would steal anything he could get his hands on." Clarence, however, did not like his job of collecting goods for shipment from various departments because the clerks called him "Indian" rather than by his name. When Pratt refused his request to return to Carlisle, Clarence went home to Pine Ridge. Luther enjoyed both his job and Philadelphia, but he did not forget his people. In 1884, when Sitting Bull and other Sioux performed in Philadelphia, he attended the performance. One of the women in the troupe asked in Lakota who his people were and, upon learning the answer, claimed Luther as a nephew. He spent the evening with them, and he later went to see a show featuring people from Rosebud, his reservation, who greeted him enthusiastically. Racism in Philadelphia ultimately forced Luther back to Carlisle. The school where he lived closed for the summer, and everywhere he sought housing, "they had no place for an Indian boy." Shortly thereafter he went back home.

The return home usually came after students had been away for six or seven years. They had left as children, and they returned as adolescents. These youths remembered their Native tongues, but they spoke like children, not adults. They had missed the instruction and rituals that should have inducted them into adulthood, and they often viewed themselves as superior to those who had not received an education. Luther Standing Bear remembered that some Carlisle students "were ashamed of their old people and refused to shake hands with them." Their own cultural traditions became the source of embarrassment: they "even tried to make them believe that they had forgotten the Sioux language." Some felt they no longer quite belonged in their tribal communities. Zitkala-Ša, on a visit home after three years at Carlisle, described herself as "neither a wild Indian nor

a tame one." At the end of her formal education, she felt stripped of her culture: "Like a slender tree, I had been uprooted from my mother, nature, and God. I was shorn of my branches, which had waved in sympathy and love for home and friends." Luther Standing Bear felt less alienation, but he recounted how his family provided a chair and table for his meals while they ate theirs sitting on the floor. Parents were hesitant to approach him about the possibility of marrying their daughters because he was an educated man, and when he did marry, his mother-in-law disapproved of the match. His refusal to take a second wife, an acceptable practice among the Sioux but contrary to his boarding school teachings, provoked such anger from the would-be-bride's brother that Luther's father had to buy the man off with several horses. Going home was not easy.

Reservations often had little to offer returning students. Although school curriculums included dry farming techniques, the agricultural instruction received on well-established farms in Pennsylvania and elsewhere had little utility in the Southwest or on the northern plains from whence many students came. The demand for skilled trades was limited, and the only employer was likely to be the U.S. agency on the reservation. Conflicts of interest between the tribe and the government often made agency jobs untenable. The mother of Zitkala-Ša explained why Dawée, the girl's brother, had lost his job at the agency: "The Indian cannot complain to the Great Father in Washington without suffering outrage for it here. Dawée tried to secure justice for our tribe in a small matter, and today you see the folly of it." Racism limited opportunity. A white man replaced Dawée. His mother lamented, "Since then Dawée has not been able to make use of the education the eastern school has given him." When Luther Standing Bear wrote John Wanamaker, who was serving as U.S. postmaster general, to request a post office at Kyle, South Dakota, the department store magnate consented, but he declined to appoint his former employee postmaster because he was an Indian.

Not all Indian students returned to reservations, and even those who did often left to find employment opportunities elsewhere. Standing Bear toured England with Buffalo Bill's Wild West show and moved to California where he worked for movie studios. A successful writer, Zitkala-Ša followed her husband, a Sioux employee of the OIA, to reservations in Utah and then moved to Washington, D.C., where she served as secretary of the Society of American Indians and worked for Indian rights. Indians ended up in all sorts of "unexpected places," as the historian Philip J. Deloria reminds us, not the least of which was the 1911 baseball World Series in which the Cahuilla catcher John Meyers faced the Anishinaabe pitcher Charles Albert Bender, a graduate of Carlisle. Such Indians, however, often encountered racism and hostility, which led some to doubt the promise of assimilation.

Former boarding school students understandably became critics of the system. Zitkala-Ša concluded that the motivation of many teachers in Indian schools was "self-preservation as much as Indian education." As for the education students received, she questioned "whether real life or long-lasting death lies beneath this semblance of civilization." Other students, however, valued their educations even when it distanced them from their culture or fostered ambitions that white prejudice thwarted. Luther Standing Bear believed that experiences like his demonstrated the capabilities of Indian people: "The Indian has just as many ounces of brains as his white brother, and with education and learning he will make a real American citizen of whom the white race will be justly proud." But even Standing Bear criticized non-Indian teachers at a reservation day school where he worked after leaving Carlisle. They taught uncomprehending children merely to recite English words "like a bunch of parrots."

The goal of educating Indians was assimilation, but policymakers worried that education alone would not accomplish that task. Children who attended day schools on reservations lived in extended families that often maintained traditional practices and

beliefs. Removing children from their families and sending them away did not change the reservations, and former students who returned home usually found ways to blend indigenous traditions with boarding school educations. Reservations separated Indians from the American mainstream and thereby reinforced Indian distinctiveness. They also promoted extended kin ties, an ethic of sharing limited resources, and tribalism. Along with the treaties that created them, reservations provided tangible evidence of tribal sovereignty and an affront to assimilation.

In the late 1860s the peace commission that toured the West to evaluate U.S. Indian policy recommended the end of treaty making. The propriety of negotiating treaties with Indians had been the subject of debate since the 1820s when Andrew Jackson railed against the practice. In 1871 Congress acted to end it. The terms of existing treaties remained in effect unless Congress specifically repealed or modified them, but after 1871 the United States would make no further treaties with Indian tribes. Henceforth, Congress enacted legislation managing Indian affairs, and Indians no longer had an equal voice in the process.

Reformers began to discuss doing away with the reservations in the 1870s, but they were unsure how to proceed. In 1881 in the midst of this quandary Crow Dog, a Brule Sioux chief, killed Spotted Tail, another Brule Sioux chief, on the Rosebud Reservation in South Dakota. Brule law, the basic principle of which was to restore harmony rather than punish the offender, settled the matter to the satisfaction of the Indians. But the Rosebud agent arrested Crow Dog and had him tried for murder in federal court. The court found Crow Dog guilty and sentenced him to hang, but Crow Dog's attorney appealed the conviction to the U.S. Supreme Court. Citing *Worcester v. Georgia* (1832), he argued that the Sioux retained their sovereign right to adjudicate such crimes and the federal government had no jurisdiction. In *ex parte Crow Dog* (1883), the court agreed and ordered Crow Dog freed. Stunned reformers

charged that the decision gave license to the Indians to kill one another without punishment and predicted that, being savages, they would surely do so. In 1885 Congress corrected the situation with the Major Crimes Act. Listing seven crimes, including murder, as so heinous they could not be trusted to tribal jurisprudence, Congress defined them as subject to federal jurisdiction.

This act was tested in 1886 when Kagama, a Hoopa Indian, killed Iyouse, another Hoopa, on the Hoopa Valley Reservation in California. Federal authorities arrested, tried, and convicted Kagama for murder. Kagama's attorney appealed to the U.S. Supreme Court, arguing that the Major Crimes Act was invalid because it violated the retained sovereignty of the Hoopa Nation. Upholding the constitutionality of the Major Crimes Act and the conviction of Kagama, the court decided that Congress had absolute authority over Indians on their reservations. In *Lone Wolf v. Hitchcock* (1903) the court applied the term "plenary power" to this concept. Reformers interpreted the Kagama decision as permission for Congress to violate the treaties that had established the reservations.

In a series of conferences at Lake Mohonk, New York, between 1883 and 1916, reformers called for dismantling reservations and granting citizenship to American Indians. Indian tribes held the land on reservations in common and governed the people who lived there within the limits imposed by U.S. law. Owning land in common, reformers thought, lay at the heart of a host of problems in Indian country that thwarted assimilation—tribal governments, extended families, and traditional values and practices. Assimilation demanded that Indians behave as individuals, not as members of a tribe or extended family, and allotting land to individuals promised to hasten that process.

Congress began debating the issue of allotting reservation land in 1880 and passed allotment legislation for specific tribes. The General Allotment Act, or Dawes Act, of 1887 applied the policy to three-fourths of Indian peoples, all except removed tribes

in eastern Oklahoma, the Senecas in New York, and the Sioux in Nebraska. The Dawes Act awarded each head of household 160 acres, each single person or orphan 80 acres, and everyone under eighteen 40 acres. The United States acted as trustee of homesteads for twenty-five years, during which time those tracts could not be sold, but the federal government had the right to sell "surplus" tribal land to non-Indians. The result was "checkerboarding," the interspersing of white and Indian landholdings. Allotted Indians became subject to the laws of the state or territory in which they lived and citizens of the United States, although subsequent legislation denied citizenship to Indians whose land continued to be held in trust. In 1893 Congress established the Dawes Commission to undertake the allotment of the five nations removed from the South to what is today eastern Oklahoma, and five years later the Curtis Act provided for the dissolution of their tribal governments.

Reformers believed that Indians had failed to exploit their forests, minerals, grazing lands, and other resources, which provided evidence that tribal holdings stifled individual ambition and economic prosperity. Indian country was ripe for the plucking, and potential pluckers were many. Lumber interests in the Great Lakes region, cattle ranchers on the plains, oil drillers in Oklahoma, expanding cities in the Northwest, and railroads across the country chafed at the restrictions placed on Indian allotments. Congress responded, first in 1902 by removing restrictions on the sale of allotments by adult heirs, and then in 1906 by empowering the secretary of the interior to remove restrictions if he determined that the allottee was competent to manage his or her affairs. The secretary also had the power to lease lands and resources with the proceeds going into individual Indian trust accounts for which the federal government failed to account accurately. Unfamiliar with trust accounts as well as real estate taxes, mortgages, and other legalities of fee simple ownership, Indian people fell victim to countless frauds.

The depths to which people sank to acquire Indian allotments had no limit. Grafters "helped" Indians select valuable allotments, leased them for a pittance, and left allottees landless. Powers of attorney, which Indians granted for small sums, became the tools for land theft. Scoundrels virtually kidnapped Indians approaching their majority and held them until, upon their eighteenth birthdays, they signed away their land. Guardians lived on the income from the allotments of their Indian wards, either orphans or "incompetent" adults, while the allotees suffered. Indians died soon after making wills that bequeathed allotments to strangers in exchange for the promise of an annuity. One white man who married an Osage woman for her oil-rich allotment systematically murdered her relatives in order to get their allotments as well. A woman from the White Earth Chippewa reservation in Minnesota observed that if Americans could, "they'd take everything.... The only thing they'd leave us with is our appetites."

Not all Indian tribes had their land allotted. Between 1887 and 1934, 118 of 213 reservations were allotted; 82 percent of the land allotted lay in Montana, South Dakota, North Dakota, Oklahoma, and New Mexico. For these people, allotment was a social and economic disaster. Indian landholding in the United States declined from approximately 138 million to 48 million acres. For those tribes subjected to allotment, land loss could be overwhelming. At the end of the twentieth century, for example, only 7 percent of White Earth Chippewa land remained in Indian hands. People who lost their allotments rented land, moved in with relatives, or drifted away to seek employment. Generally, the land Indians retained was far less desirable than that lost. Many people could not make a living from their allotments and ended up leasing their land; the proceeds went into individual trust accounts, which the Interior Department controlled. Among many tribes, allotment created or exacerbated factionalism between Indians deemed "competent," often on the basis of ancestry, and those who were not, a distinction that resulted in the removal of restrictions

and citizenship for some but not others. The closing of reservation schools placed Indian children in non-Indian schools where they were not welcomed, and a lack of education further restricted opportunity. Growing poverty precipitated a decline in health, and the rates of communicable diseases like tuberculosis soared.

By the 1920s, calls for reform were mounting. Among the voices decrying the plight of Native people was the Society of American Indians. Organized in 1911 by Indian intellectuals and activists, the Society of American Indians promoted assimilation, but its members criticized the federal bureaucracy that had so bungled Indian affairs and insisted on respect for Indian rights. In 1924 Congress acceded to one of their demands and extended U.S. citizenship to all Indians. Two years later, the Interior Department commissioned a study of the administration of Indian affairs, released in 1928. The resulting Meriam Report (or as it was known "The Problem of Indian Administration") scrupulously documented the poverty of American Indians and placed the blame squarely on allotment. The stock market crash and the beginning of the Great Depression precluded any immediate action; formal abandonment of the policy came with the New Deal.

Chapter 6
Political sovereignty and economic autonomy

President Franklin Roosevelt appointed John Collier commissioner of Indian affairs in 1933. A social worker by profession and an activist in the Indian reform movement, Collier entered office with the intention of transforming U.S. Indian policy. Personal experience in Indian country and the scathing indictment of federal policy contained in the Meriam Commission report convinced Collier that the allotment policy had to be overturned, that the wreckage caused Indians had to be reversed, and that Native cultures merited respect and encouragement. Collier's twelve-year tenure as commissioner, although checkered, represents a truly revolutionary period in American Indian history.

Collier's reforms were rooted in his thinking about culture. A relativist, he rejected the idea that some cultures were superior to others. Instead, he embraced the emerging anthropological view that all cultures make sense, work well, and serve the needs of the people who create them. Programs like allotment rested on the contrary belief that Indian cultures were inferior, primitive, incompatible with modern life, and deserving of replacement by contemporary American culture. Collier's dedication to the revitalization and preservation of Native cultures is the principle that binds together many features of his Indian policy. He began by rescinding the orders of his predecessors that prohibited

traditional religious ceremonies and dances on reservations and that required all students at federal boarding schools to attend Christian church services. A renewal of federal recognition of tribal sovereignty became important to Collier because he believed that the revitalization of Native cultures depended on the ability of the tribes to govern themselves.

The centerpiece of Collier's overhaul of Indian policy may be found in the Indian Reorganization Act (IRA), enacted by Congress in 1934. A diluted version of the commissioner's draft, the act nevertheless put in place much of his program. Most critically, it repealed the policy of allotment, extended indefinitely the trust restrictions on individual allotments, authorized the restoration of unsold surplus lands to tribal authority, and appropriated $2 million per year for the purchase of additional lands for the reservations. These provisions reflected Collier's conviction that tribal viability depended on an adequate land base. Beyond that, the IRA called for a rebuilding of the political infrastructure of the reservations. Collier, who accepted the picture of utter despair painted by the Meriam Commission, argued that his purpose of revitalizing tribalism had to assume that nothing remained on which to build. The IRA proposed that the tribes create constitutional governments of three branches managed by popular elections and democratic principles. To achieve the enormous task of economic development, constitutional tribal governments could incorporate themselves for purposes of managing reservation property. A $10-million revolving loan fund would provide investment capital. And finally, the IRA authorized the OIA to recruit Indian employees without reference to federal civil service laws. This last proposal has created a Bureau of Indian Affairs (BIA), as the OIA became known in 1947, which is staffed almost entirely by Native people.

Critics expressed themselves even before the passage of the IRA. Non-Indians opposed the reversal of powerful old ideas about the need for culture change and assimilation. Remaining convinced

that tribalism was an anachronism, they found the IRA a huge step backward. Others still thought that valuable reservation land should remain available in the marketplace. Many Indians shared these reactions. For them, allotment had brought opportunity; they had entered the American mainstream, and they wanted to stay there. Larger numbers of Indians, remembering generations of bad ideas bombarding them from Washington, simply could not believe that the commissioner of Indian affairs could be a sympathetic friend bearing beneficial programs. Collier had agreed to a stipulation contained in the IRA that made tribal acceptance of its provisions voluntary. By 1936, 177 tribes voted to embrace the opportunities of the IRA, 77 voted not to. Any tribal opposition upset Collier, who was totally confident in the righteousness of his program, but the rejection by the Navajo Nation stunned him.

The Navajos comprised the largest Native nation and, suffering extreme economic stress, the Navajos by all appearances would have benefited significantly from the terms of the IRA. But the Navajo Nation had not been allotted and had not, therefore, experienced the political and social collapse that was inherent in allotment. The nation was deeply divided between two political factions. One led by Chee Dodge, former chairman of the Navajo Tribal Council, supported the IRA because he believed it would strengthen Navajo sovereignty. Opposed was Jacob Morgan, a well-educated Christian who rejected the principles of Collier's Indian New Deal. The government's stock reduction scheme also influenced the Navajo vote. Various studies had convinced Collier that the Navajos ran about three times as many sheep, goats, horses, and cattle than the reservation could sustain. Initial efforts to convince the Navajos to reduce their herds voluntarily, a program Dodge accepted and Morgan opposed, failed. Ultimately, the OIA pursued forcible measures. Identification of stock reduction with Collier and the IRA contributed to Navajo rejection of the IRA, but the vote was very close, indicating that nearly half of the population was willing to approve it.

The provisions of the IRA did not extend to the Indians of Oklahoma. That state's politicians opposed anything that could strengthen the rights of Native governments over land and resources, especially oil, and many Oklahoma Indians opposed a return to tribalism and traditional culture. Indeed, Joseph Bruner, a Creek from Oklahoma, led the most outspoken national Indian organization opposed to Collier's Indian New Deal. But most Oklahoma Indians wanted access to the economic development opportunities of the IRA. In 1936 Congress accommodated them with the Oklahoma Indian Welfare Act.

Indian critics increasingly attacked the political assumptions of the IRA. Like the Navajo Nation, nearly half of the reservations had not been allotted, and their political institutions had not been dismantled. They were often uncomfortable with what they considered the alien political concepts of majority rule, popular election, and constitutionalism that the IRA required. So were some nations that had been allotted. In a bizarre contradiction, Collier argued the virtues of cultural relativism and tribal sovereignty while simultaneously insisting that the tribes embrace a package of foreign governmental practices. Furthermore, virtually every stage in the development and operation of tribal governments required ratification by the secretary of interior. Indian critics pointed out that such paternalism hardly squared with reformist talk about tribal sovereignty. Non-Indian critics found Collier arrogant in his manner and his principles threatening. A socialist if not a Communist, an agnostic if not an atheist, Collier held ideas that many agreed were unacceptably alien.

The greatest threat to Collier's policy revolution came not from his critics, however, but from the economic realities of the Great Depression. Indian policy was not high on the agenda of anyone in Congress, and in times of fiscal crisis, it was easy to cut appropriations and leave mandates unfunded. Even the provisions of the IRA, grossly reduced from Collier's original

draft, proved too expensive. Collier took up some of the slack by attaching Indians to other New Deal initiatives like the Civilian Conservation Corps and the Works Progress Administration, but they fell far short of adequate. By the time of World War II Collier could recount with pride that he had ended allotment and sparked cultural revitalization, in themselves revolutionary achievements, but he could point to little else.

World War II was in many ways an even more profound revolution for Indians. In 1940 the Native population of the United States stood at about 345,000. More than 90 percent of Indians lived in reservation communities. Except for those who had attended off-reservation boarding schools, few had traveled outside of Indian country, few spoke English well, fewer were literate in English, and almost none was acquainted with modern American life. Twenty-five thousand wore a uniform during the war. They served in integrated units, giving them their first intimate experiences with non-Indian people. They won promotion and exercised command responsibilities over non-Indians. They used their languages to develop codes that defied enemy eavesdroppers, and they won medals for heroism. They learned that they could adapt, function, and succeed in the non-Indian world.

Nearly fifty thousand more Indian men and women left their reservations to work in war-related industries. Many remained close to home on farms and ranches, but many more went to distant cities, worked in factories, lived in apartments, made decisions, and enjoyed such luxuries as electric lighting and indoor plumbing. Living as responsible adults and treated as such, they survived without the paternalistic supervision that characterized their lives on their reservations. After the war, some stayed in the cities if they could hold onto their jobs. Most returned home. But when they arrived they were not the same men and women who had left. They were self-confident, accomplished, and far less tolerant of government paternalism than they had been.

On reservations, finding employment for returning veterans and defense workers was difficult, often impossible. The problem seemed especially pressing at Navajo. In response, to 1948 the BIA opened offices on the reservation to help employable people to relocate to Salt Lake City, Denver, and Los Angeles. The tribal government supported such efforts. By the early 1950s relocation came to be seen in Washington as an attractive companion to the emergent federal policy of terminating government relations with the tribes. In 1954 the BIA organized a Relocation Branch in several cities, opened recruitment offices on forty-five reservations, and developed a program that included transportation, help for employment and housing, and, for those without urban experience, instruction in the mysteries of American culture. Between 1940 and 1960 roughly 122,000 Indian people resettled in urban America, about one-fourth of them under the auspices of the BIA. For some, adjustment to urban life was too difficult to endure, but most remained and carved out lives for themselves. Migrants created multitribal Indian communities, social and cultural centers, and an infrastructure that provided support. Relocation as a policy did not survive the 1960s, but the migration to urban areas by Native people continued unabated. At the beginning of the twenty-first century, more than two-thirds of American Indians live in cities rather than on reservations.

The termination policy that absorbed relocation in the 1950s grew out of opposition to Collier's ideas and a larger backlash against the New Deal. Conservative politicians were eager to reduce government costs, especially for what they defined as public interventions into the private sphere. In Indian policy, termination was in many respects a throwback to the allotment period when government worked to eradicate tribalism, implement programs of forced culture change, and assimilate Indian people into the mainstream of American life. Termination was different only in that the agencies of culture change were sidelined. Instead, the policy aimed at backing away from the service responsibility

embedded in the trust doctrine, erasing the government-to-government relation that rested on the concept of tribal sovereignty, and dumping Native people into the mainstream. Congress expressed itself in 1953 with House Concurrent Resolution 108. Not a piece of binding legislation, it announced the "sense of Congress" that many tribes did not need a relation with the government and that without one the people would be freed to prosper on their own. Congress accompanied this resolution with Public Law 280, which granted to several states the authority to extend civil and criminal jurisdiction onto the reservations.

No tribe wished termination but several, either by direct force or intimidation, were compelled to submit. Among them were dozens of tiny California Indian communities, tribes in Utah and Texas, the Catawbas in South Carolina, and two fairly prosperous timber tribes, the Klamaths of Oregon and the Menominees of Wisconsin. The effect of termination on the tribes was uniformly disastrous, most apparently so among the Klamaths and Menominees. Both groups managed logging enterprises that provided employment and income that enabled the tribes to fund needed services for their citizenry. Termination closed the tribal sawmills, opened the forests to non-Indian exploitation, and transformed the communities from prosperity to poverty. In the end, termination came to only about thirteen thousand Indians, but the fear of it hung like a toxic cloud over Indian country for nearly a quarter century.

The terminationist mentality of the postwar period led Congress in 1946 to create the Indian Claims Commission (ICC), a court of claims dedicated to hearing suits brought by tribes against the United States, mostly for treaty violations or for having paid unconscionably low prices for land purchased in the nineteenth century. The idea actually originated with Collier in the 1930s, but Congress adopted it to settle all outstanding Indian issues as part of the broader program of termination. By the time the ICC was finally disbanded in 1978, it had awarded over $800 million

to Indian tribes. Aside from the cash, an important benefit to this program was that it encouraged tribal governments to develop plans to administer the money.

The Alaska Native Claims Settlement Act (ANCSA), passed by Congress December 18, 1971, is part of this history of the ICC and Congressional policy to settle questions of Indian rights and claims. When the United States acquired Alaska in 1867 it was populated almost exclusively by Native people. Inuits and others often referred to as Eskimos inhabited the northern and western coastal areas while Indian groups lived further to the south and in the interior. Some had participated in the fur trade with Europeans and Anglo-Americans, but many had not and the cultures of none had been significantly changed by the outside world. The gold rush at the end of the nineteenth century brought non-Indians to the territory, but for most Natives little changed until the industrialization of fishing in the twentieth century. Growing non-Indian population and pressure for statehood led to the admission of Alaska into the union in 1959, but even then the status of Alaska Natives remained uncertain.

U.S. Indian policy did not apply in Alaska, and Native rights to the land were both undefined and unprotected. This vague and confused situation became critical during the 1960s when Atlantic Richfield discovered huge oil deposits on the North Slope and made plans to construct a pipeline across the state. Native groups began to organize in 1963 to assert their aboriginal title to the land, and by 1968 they had filed claims with the BIA on about 80 percent of Alaska. In 1969 the secretary of the interior ordered a freeze on all land transfers until the rights of Alaska Natives were determined. The purpose of ANCSA was to settle these questions and open the way for the development of the oil reserves. The act abrogated Native claims to aboriginal lands, established a system of Native corporations, and awarded to them more than $950 million and about 44 million acres to be held by the corporations in fee simple title.

Much about the law is controversial, especially the provisions for incorporation, and it has been amended many times. Furthermore, many Alaska Natives fear that they gave up too much when they surrendered their claims to aboriginal title. In the mid-1990s assistant secretary of the interior for Indian affairs Ada Deer ordered that more than two hundred Alaska Native communities be acknowledged as sovereign, which alleviated much of the concern over the long-term implications of ANCSA. Like the ICC, Congress enacted ANCSA to serve its own purposes, and the interests of Native Alaskans were not a priority. But also like the story of the ICC, Native people have worked to make federal policy serve their needs.

The termination policy also motivated the transfer in 1955 of the Indian Health Service out of the BIA and to the Public Health Service of the newly created Department of Health, Education, and Welfare. No one could deny that the standards of health care delivery to Indian people, a trust obligation, were unacceptable. Critics generally blamed the well-known inefficiency of the BIA and argued that the Public Health Service could improve the level of care for Indians, a view that fit nicely with the goal of ultimately abolishing the BIA along with the trust obligations it administered. Achieving the promises of vastly improved health care for Indians under the direction of the Public Health Service has proved illusory.

Congress formally rejected termination in 1975 but as policy it was moribund by the late 1950s. Its godfather, Senator Arthur Watkins of Utah, lost his bid for reelection in 1956, the secretary of the interior Fred Seaton announced in 1958 that future terminations would occur only with the willing agreement of the tribes, and Congress generally just lost interest. But most importantly, the Indians themselves killed it. In 1944 D'Arcy McNickle, a Flathead anthropologist and high-ranking official in the BIA, and others founded the National Congress of American Indians. NCAI is a multitribal organization, the purpose of which is to defend and

strengthen the sovereign rights and powers of the tribes by lobbying Congress, testifying at hearings, publicizing issues, and organizing meetings. NCAI's comprehensive attack on termination convinced many that it was a disaster for Indians. The successful campaign by NCAI was unprecedented. No Indian organization had ever before reversed federal Indian policy through political action.

Dismal reports of several presidential commissions and study groups assigned during the 1960s and early '70s to study reservation conditions agreed with NCAI that termination should be rejected. Finally, in 1975, Congress enacted the Self-Determination and Education Assistance Act that repealed termination in favor of the policy of self-determination, the policy that defines the relation between the United States and the tribes today. In the spirit of the rejection of termination, between 1973 and 1990 Congress reinstated full recognition and services to nine of the terminated tribes.

Congress did not define carefully what it meant by self-determination, but tribal leaders thought they knew— self-determination was another way to say tribal sovereignty. Since Collier's Indian New Deal, tribal leaders had been struggling to put sovereignty to work. Their post–World War II attacks on BIA paternalism had kept the goal of sovereignty alive. The campaign against termination waged by NCAI reflected its devotion to tribal sovereignty, and in 1961, in concert with a group of activist anthropologists, it convened a landmark conference on the campus of the University of Chicago to devise a policy of Indian design to present to the newly installed administration of President John F. Kennedy. The American Indian Chicago Conference seated nearly five hundred delegates from sixty-seven tribes and adopted a "Declaration of Indian Purpose" outlining a federal approach that respected tribal sovereignty and rejected paternalism.

Many in the audience, primarily young Native college students who sneered at the representatives of tribal governments who wore

three-piece suits, looked and acted like bankers, and drafted a
memorandum that requested rather than demanded, left Chicago
frustrated and impatient. Gathering in Gallup, New Mexico, later
that summer, they formed the National Indian Youth Council
(NIYC). Guided by the charismatic Ponca Clyde Warrior, NIYC
called on the tribes to school their youth in tribal rather than
American values and devise a future in which Indian people
created their own destiny. Influenced by the public activism of the
Black Power movement, NIYC coined the term "Red Power" and
launched a program of protest. Among its most influential actions,
NIYC joined Native fishermen in the state of Washington to fight,
both on the rivers and in the courts, for their sovereign right to fish
in their traditional ways and places free from the regulation of the
state Fish and Game Commission. The Boldt decision, named for
the federal judge who rendered it in 1974, recognized the
treaty-based rights that the Indians demanded.

The American Indian Movement (AIM) learned from NIYC.
Formed in Minneapolis in 1968 as a neighborhood watch against
police harassment, AIM grew into an activist urban cultural and
political organization, which mastered the art of confrontational
politics and manipulation of the news media. Russell Means,
an Oglala Sioux whose family's roots were in the Pine Ridge
reservation of South Dakota, became a staple on the nightly news.
Handsome, colorful, and articulate, Means led occupations of
Plymouth Rock and the *Mayflower* replica in Massachusetts,
Mount Rushmore in South Dakota, and the BIA headquarters in
Washington. In 1973 he was part of the group that for seventy-three
days held out against a full array of government force at Wounded
Knee. Different in detail, AIM, NIYC, and NCAI agreed on
basic principles, chief of which was tribal sovereignty. The Self-
Determination Act of 1975, which recognized that principle, came
in the wake of many years of activism.

The Self-Determination Act provided for a contracting system
that tribes found immediately useful. To fulfill its trust obligation,

the BIA administered specific services, among which were schools, resource management, housing, policing, and road construction and maintenance. The BIA budgeted a sum for each service for each reservation. The Self-Determination Act enabled a tribe to contract with the BIA to administer a specific service itself. The BIA paid the tribe the money allocated, and the tribe managed the work. The BIA approved such contracts only if the tribe had in place management institutions necessary to administer the program, which encouraged tribes to develop such capacity and thereby continue their evolution toward fully capable sovereign nations.

In contracting, money approved for one service cannot be diverted to support another. This restriction reflected unwillingness by the BIA to shift from service provider and manager to merely a funding source, and it denied the tribes the ability to make complex planning decisions or act quickly to meet unexpected needs. In reaction to complaints brought by tribal officials, in 1988 Congress passed the Tribal Self-Governance Demonstration Project Act, which permitted a select group of tribes to receive block grants from the BIA to cover all trust services according to their own priorities. The plan proved successful, and in 1994 Congress made the system permanent. Block grants, called compacts, were voluntary but popular enough that 230 tribes participated in the program by 2004. Tribes worked hard to build the government institutions necessary to manage the services that trust obligation required of the BIA but, because they remained dependent on federal money, they could not fully enjoy the kind of political sovereignty they sought. Political sovereignty did not mean much in the face of economic dependency.

After World War II, economic development was at the top of the agendas of virtually every reservation. Unemployment was almost universal, family incomes were virtually nil, and the tribes had no income beyond government appropriations to the BIA. Some reservations did have natural resources. Some tribes own

important timber reserves, but mineral resources attracted most postwar attention. Thirty percent of the low-sulfur coal west of the Mississippi is on Indian land, as is 5 to 10 percent of the oil and gas and some 50 to 80 percent of the uranium. Congress enacted legislation in 1918 and again in 1938 to authorize the secretary of the interior to negotiate leases to develop tribal mineral resources. Stipulations in these acts set royalties below those demanded for similar activity on government land and omitted provisions for periodic renegotiation of the contracts.

The Navajo reservation is especially rich in oil, uranium, and coal. Oil exploration began before World War II, and in the 1950s a huge strike generated major interest. The Cold War created a market for uranium, which Navajo mines largely supplied until 1982 when they closed. The most important Navajo resource, however, is coal. Coal underlies much of the Navajo reservation, and Black Mesa, which the Navajos share with the Hopis, is a virtual mountain of coal. As early as 1943 the Navajo tribal council had begun to explore the possibility of developing its coal, but there was no market. The postwar population explosion in southern California, Arizona, and Nevada created an unprecedented demand for electricity that changed everything. Twenty power companies formed a consortium, which drew up plans for a huge power grid anchored by a series of coal fired power plants located adjacent to the Navajo reservation. Black Mesa coal would provide the fuel, and Peabody Coal Company of Denver would mine it.

Mining coal on such a scale is an enormously complicated and expensive business. Both the Indians and the Interior Department lacked the necessary expertise to understand all that was involved. But Peabody and its attorneys knew. Chicanery, fraud, manipulation, and ignorance marked the arrangement. By the end of the 1960s the Navajo and Hopi tribal councils had signed the necessary contracts and the enterprise was under way. The going market price for coal at the time was $4.40 per ton, $1.50 of which was the standard payment to the owner. The contract

concluded between Peabody Coal and the Interior Department provided seventeen cents per ton to the tribes with no provision for renegotiation if the price of coal went up. In 1973, during the time of the OPEC oil embargo, the price of coal reached fifteen dollars per ton. The Navajos and Hopis, the owners of the coal, continued to receive seventeen cents.

In 1975 the mineral-rich tribes organized the Council of Energy Resource Tribes (CERT) in hopes of improving their situation relative to the mining companies. CERT hired experts, commissioned surveys, developed a library, and positioned itself to provide the tribes with expert advice on how to gain better control over their resources and prevent the kind of exploitation experienced by the Navajos and Hopis. The Jicarilla Apaches of New Mexico, caught in a similar situation, enacted a severance tax on the oil and gas pumped from their reservation. Amoco challenged the tribe's right to do so. In 1982 the Supreme Court upheld the authority of the sovereign Jicarilla nation to levy the tax and opened the way for other tribes to follow suit.

The story of Black Mesa is perhaps the most disgraceful, but it is by no means the only example of resource-rich tribes being swindled by the sweetheart deals concluded by power, mining, and oil companies and the Interior Department for rights to Indian-owned minerals. Congress attempted to fix things in 1982 with the Indian Mineral Development Act, which recognized the right of the tribes to develop their own minerals. The exploitation of oil, coal, and other resources can provide jobs and income, but doing so is controversial. Coal strip mines are ugly and cause a great deal of environmental damage. Coal-fired power plants emit pollution that fouls the air for hundreds of miles, and they require enormous amounts of water, which in the desert southwest is scarce. But the tribal governments need income and the people need jobs.

All of these schemes for breathing new economic life into the reservations share serious disabilities. Contracting and

compacting depend on unpredictable government appropriations, and the heavy hand of the BIA is present everywhere. The controlling power in the exploitation of natural resources lies in the Department of the Interior and the mining and energy companies. Tribes receive royalty payments, but the profits generated by the development of tribal resources belong to the corporations and leave the reservations. Neither plan provides the tribes with the investment capital necessary to create meaningful economic autonomy.

President Lyndon Johnson's short-lived war on poverty held out some hope. Congress rooted the Office of Economic Opportunity (OEO), established in 1964, in the novel idea that the poor should take the lead in identifying their economic problems and developing the means to solve them. The Community Action Programs (CAP) were central to this concept, and Congress made the tribes eligible. Tribal governments decided their priorities, applied for grants, and managed the money to achieve their goals. CAP programs operated outside the control of the BIA and gave tribes a level of control that they could not otherwise enjoy. One of the most spectacularly successful economic development programs in Indian country, the so-called Choctaw Miracle, began with a CAP grant of $15,000 to enable the Mississippi Band of Choctaws to establish a bookkeeping system. Philip Martin, chief of the tribe, then acquired a second grant to set up programs for planning, accounting, and personnel management. So armed, Martin canvassed corporate America looking for companies willing to locate in Mississippi. Next came an industrial park, and in 1978 Packard Electric agreed to bring its operation for assembling wiring harnesses for automobiles to the Choctaw reservation. Success bred more success, the Choctaws accumulated capital and invested in more projects, and by the 1990s the Mississippi Band was one of the largest employers in the state. Most CAP grants led to more modest accomplishments, but all provided the means for economic development based on tribal initiative, encouraged the maturation of tribal institutions, and financed a future that was

not subject to the administrative control of the BIA. When self-determination became official federal policy in 1975, some tribes, already experienced with a degree of economic autonomy, were ready to exercise their sovereign powers.

Tribes experimented with many models to achieve their goals but the road to success was clearly connected to sovereign status. One of Martin's selling points as he marketed the Choctaws to corporate America was that the laws and regulations that applied elsewhere did not exist on the Choctaw reservation. Other tribes exploited their sovereignty by opening shops that sold goods that states heavily taxed, usually gasoline and tobacco products. Because state law did not extend to reservations, they could sell these goods free of state tax. The Seminole Tribe of Florida first ran "smoke shops" and then took the short step to bingo. Florida bingo parlors operated under state regulations that placed a limit of $100 on the amount a player could win. Seminole bingo, initiated in Fort Lauderdale in 1979, offered $100,000 jackpots and attracted huge crowds. The Seminoles reasoned that profits from bingo could finance educational, health, housing, and other programs, and generate investment capital for other economic development projects.

The sheriff of Broward County warned the Seminoles that they were in violation of the law by exceeding the jackpot limit. The Seminole government countered that tribal sovereignty meant that it was not subject to the state regulation. In *Seminole Tribe of Florida v. Butterfield* (1982), the U.S. Supreme Court agreed with the Seminole argument: tribal sovereignty blocked the application of state regulatory law on a reservation. *California v. Cabazon Band of Mission Indians* (1987) was a bit different because poker was at issue, but citing that the intent of Congress was to encourage tribal self-determination and economic development, the court affirmed its earlier decision by ruling that tribal sovereignty trumped state regulation. These two decisions opened the way for casino gambling on reservations.

Casino profits could be staggering, reservations could be transformed, investment opportunities seemed limitless, and tribal governments could begin to think that the decades of grinding poverty were past. In 1986 the gaming tribes formed the National Indian Gaming Association, a lobby organization dedicated to representing the interests of the incipient enterprise in Washington. New Indian casinos opened, and private gambling interests were terrified. Subject to state regulations, including taxes, non-Indian casino owners feared that they could not compete with tribal operations. The states, facing the prospect of casinos within their borders over which they had no control, worried about the possibility of infestation by organized crime, dreaded the costs of highways, policing, and crowd management adjacent to the reservations, and resented the loss of tax revenue. All these anxieties commanded attention in Congress. Acting in the wake of the *Cabazon* decision and eager to serve their non-Indian constituents, in 1988 Congress passed the Indian Gaming Regulatory Act (IGRA). Its three purposes were to encourage tribal economic development, protect the tribes from organized crime, and assure the states a role in tribal gaming. This last purpose has required that tribes operating casinos surrender certain sovereign rights.

Aside from requiring the tribes to establish systems for organizing, managing, and accounting, IGRA divided gaming into three classes. Class I was traditional gambling and outside the regulatory purview. Class II included bingo, black jack, poker and other nonbanking card games. The idea was that class II games required intelligent decision making on the part of the player. Class III games were banking card games, craps, horse and dog racing, and slot machines, games determined by luck. If any one of the class II games was legal in a state, a tribe could offer all the games defined as class II in its casino. The same for class III except that because these are the big money games, especially slot machines, a tribe must negotiate an agreement with the state governor that establishes regulatory systems and

defines the role of the state in the enterprise. As originally written, the law required the governors to negotiate in good faith with the tribes and gave the tribes the right to sue if necessary to force negotiation. A 1996 Supreme Court decision denied the tribes the power to sue, meaning that a governor who does not want class III games in his state can block them, despite the sovereignty of the tribe. Or, as usually happens, he can force the tribe to pay for the privilege of operating class III gaming. Often the price is a percentage of slot machine profits. For a time, the profitability of slot machines seemed to make the payment, often as much as 25 percent, worth it. It has certainly paid off for the states. Nationwide, Indian casinos paid state and local governments $1.2 billion in 2006. But the industry has developed slot-like machines that qualify as class II. This innovation removes the requirement to negotiate with governors and pay into state treasuries, thus preserving casino profits and tribal sovereignty uncompromised.

In 2006 tribal gaming was a $25.7 billion industry. Of 564 federally recognized tribes, 225 operated 423 class II and class III casinos, employed well over three hundred thousand people, and paid over $11 billion in wages. Some casinos, such as Foxwoods, the operation of the Mashantucket Pequots in Connecticut, are huge and have been enormously profitable. Twenty casinos well located near cities or busy interstate highways generate more than half of the income; the rest are much more modest operations.

The tribes use their money in a variety of ways, but the foundational goal is jobs for tribal people and income for tribal purposes. All the tribes spend on tribal infrastructure. They build and operate schools, hospitals and clinics, elder care facilities, wellness centers, housing, scholarships, and a host of other things. Assuming that casino gaming will not persist at current levels indefinitely, they also invest in other businesses. The richest tribes also donate large sums to worthy causes—$10 million of Foxwoods profits went to fund the Smithsonian Institution's National Museum of the American Indian. Casino tribes have

become politically active by contributing large amounts of money to the political action committees of politicians known to be friendly to Indian issues. About one-fourth of the casino tribes pay a portion of their profits directly to tribal citizens. For some, these per capita payments provide very comfortable livings.

The attraction of gaming is obvious. The income is free from the paternalistic control of the government. Like CAP grants, but on a much grander scale, tribal priorities prevail. In a way that could hardly be imagined just a few short decades ago, gaming money provides economic security and autonomy. Dependent on the full exercise of political sovereignty, the casinos also reinforce sovereignty, strengthen and vitalize it, and give full meaning to the theory of tribal self-determination that finally reversed allotment and termination.

The extraordinary success of tribal gaming has generated a great deal of controversy. Non-Indians often resent the presence of casinos in their neighborhoods, state and local governments chafe at their inability to regulate such wealthy enterprises, competitors think that sovereignty gives tribes an unfair advantage, others believe that the notion of rich Indians is an unacceptable oxymoron, and many oppose gambling of any kind for moral reasons. Put together, these attitudes add up to a large backlash against tribal sovereignty, which has significant power. Local campaigns, congressional hearings, and a host of hostile proposals reflect a degree of ill will that has had consequences. One of the most unfortunate has been the suspicion directed against Indian communities, which, for a variety of reasons, are not acknowledged by the federal government as sovereign tribes and therefore do not enjoy government-to-government relations with the United States.

There are at least 324 unacknowledged Indian communities in the United States. They are scattered throughout the country, but many are concentrated in the East where they had been

surrounded and marginalized by non-Indian settlements long before the establishment of constitutional government in 1789. Many of them seek acknowledgment; some have for well over one hundred years. In 1978 the BIA developed a procedure to study their applications and, if approved, to extend acknowledgment. The procedure, designed by people using the western reservation tribes as their model, is very difficult for unacknowledged groups to satisfy. Communities must demonstrate their existence since 1900 as tribes with social and political institutions, along with local recognition and genealogical verification as Indian people. By September 2008, eighty-two communities had submitted petitions, often thousands of pages long, seeking acknowledgment. The BIA process resolved forty-four of them, sixteen favorably, twenty-eight denied. Since acknowledgment of their status as sovereign Indian nations, five have opened casinos. Critics argue that most of the unacknowledged groups are pretenders simply trying to jump on the rich casino bandwagon. The evidence suggests that in the case of some, the critics are correct. But not all claimant groups are fraudulent, they deserve acknowledgment, and their efforts to achieve it have been stymied by the political power of the enemies of tribal gaming.

The sovereign existence of the nations of Native America is central to their story. Preserving sovereignty has never been easy, and it has not survived fully intact. The U.S. Supreme Court first articulated tribal sovereignty in 1832 and reaffirmed the principle in 1959 in *Williams v. Lee*. Judicial opinions since then have been inconsistent in defining the parameters of tribal sovereignty, but no court, no matter how unfriendly, has rejected it. But the court has also never overturned an act of Congress relating to Indians, which means that congressional challenges to tribal sovereignty carry a dangerous degree of immunity. According to the census of 2000, there are 4.3 million American Indians and Alaska Natives in the United States, 1.5 percent of the total population. Because they are scattered throughout the country, their numbers are concentrated in only a few places. Although their votes can

influence the outcome of congressional elections in a handful of districts in South Dakota, Arizona, and New Mexico, they will never be able to exercise controlling political power anywhere outside their reservation boundaries. And because congressional plenary power in Indian affairs empowers Congress to do whatever it wishes, Native people cannot defend themselves alone. To preserve the gains they have made, Indians need friends who are willing to help them protect tribal sovereignty.

Chapter 7
Cultural sovereignty

Just as Native peoples struggled to retain their political sovereignty, they also sought to represent themselves in ways that acknowledged diversity, countered stereotypes, and allowed for change. The fiction of "Indian" has permitted the development of stereotypes depicting Native peoples as the "Other," the opposite of civilized Christian Europeans. The most common stereotypes center on savagery or primitivism. One of the earliest American literary works, *The Sovereignty and Goodness of God: Being a Narrative of the Captivity and Restoration of Mrs. Mary Rowlandson* (1682), chronicled the experiences of a Massachusetts woman taken in 1675 during King Philip's War by people she described as "merciless heathens" and "barbarous creatures," a depiction that found new currency in the mid-nineteenth century. In the eighteenth century, another stereotype challenged the "Indian as savage" trope. Enlightenment writers idealized Indians as natural beings, shaped by the unsullied environment rather than the edifices of men. In subsequent periods when Euro-Americans were disillusioned with their built environment, especially industrialization and urban life, they seized upon this stereotype of Indians. The arts and crafts movement of the early twentieth century, a reaction to mass-produced decorative items, put Navajo rugs on the floors of easterners and brought the San Ildefonso potter Maria Martínez national acclaim. More recently,

Indians have served as a symbol for the environmental movement because the American public perceives them as being particularly sensitive to littering and other forms of ecological abuse.

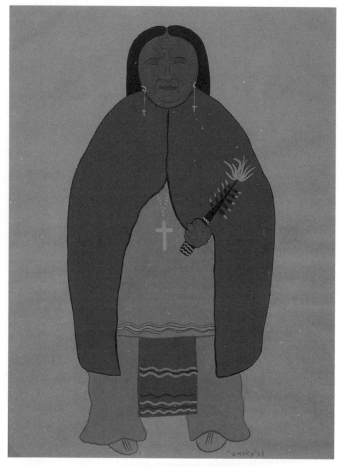

9. Lois Smoky, *Kiowa Indian Ghost Dancer* (1933). Though not appreciated at the time, Smoky is now considered to be one of the pioneers of the "traditional" style developed in Santa Fe and at the Kiowa Agency in Oklahoma in the 1920s and 1930s.

All stereotypes of Indians deny them the ability to change, thereby relegating them to the past and condemning them to extinction. James Fenimore Cooper's work, most famously *The Last of the Mohicans*, had its share of savage Indians as well as noble ones, but none of them had a role to play in nineteenth-century America. Their static culture locked them forever in the past. In the early twentieth century, Americans wanted to see the famous Apache Geronimo riding his war pony not driving his Cadillac. When Indians have changed, they find their cultural authenticity questioned. If an Indian does not wear long hair and turquoise jewelry, seek visions, respect nature, and dance to a beating drum, can that person be a real Indian? Is an Indian who lives in a city, has a college degree, and practices a profession authentic?

Indigenous peoples have contested European depictions of them. The broad array of beliefs and ceremonies, languages, subsistence strategies, polities, and cultural traditions dramatized their differences. Native people also proved capable of change even in something as fundamental as accounts of the creation. In the Southeast, for example, Creek narratives emerged explaining the presence of black and white people in the world. The Creator baked one man too long, one too little, and the Creek just right. Though new, this account confirmed a deeply held belief: Creeks were different from other peoples—and superior to them.

Native people tried to make Europeans understand the logic of their ways of life. At the Treaty of Greenville (1795), the Wyandot headman Tarhe explained relationships between tribes in terms of kinship, something so fundamental, he thought, that Europeans surely would understand it. Native people sought explanations for how European society worked, and they often implied that they found it bizarre. A Cherokee headman, accustomed to the public presence of women, asked the South Carolina governor why no white women attended their councils, noting quite logically that "White Men as well as the Red were born of Women." Indians also produced their own histories of the encounter. In his "Eulogy on

King Philip" (1836), William Apess contended that "the whites have always been the aggressors, and the wars, cruelties, and bloodshed is a job of their own seeking, not the Indians," a view at odds with that of Mary Rowlandson. Non-Indians usually dismissed Native explanations of their histories and customs as the musings of savages and paid little attention to the coherent worldview and narrative they embodied.

Indians consistently challenged white representations of them. In 1826 Elias Boudinot, a Cherokee, embarked on a speaking tour of the Northeast to raise funds for the purchase of a printing press and type in the Cherokee syllabary, a writing system invented by Sequoyah. A year earlier, the Cherokee council had authorized publication of a bilingual newspaper, the *Cherokee Phoenix*, and appointed Boudinot editor. Boudinot challenged audiences to abandon "repelling and degrading" ideas about Indians. "What is an Indian?" he asked. "Is he not formed with the same materials as yourself?" Then the educated, well-dressed young man asserted, "You here behold an *Indian*." He went on to chronicle the achievements of the Cherokee Nation, which he hoped would entitle it to "an equal standing with other nations of the earth."

By the end of the nineteenth century, Indians regularly lectured in halls across the country. Following his U.S. court victory in 1879 that recognized an Indian right to writs of *habeas corpus*, that is, legal personhood, the Ponca chief Standing Bear toured the United States in the company of the Omahas Francis and Susette La Flesche in order to press for the recognition of Indian rights. In 1883 the Paiute Sarah Winnemucca passionately denounced treatment of her people by the Office of Indian Affairs and its corrupt agents on an eastern tour. She wore an elaborately beaded buckskin dress to make sure that her audience understood that they were hearing about Native people from an Indian. The Yavapai Carlos Montezuma, the Sioux Zitkala-Ša, and scores of other Native people called attention to the desperate need for reform in Indian policy. Most of these lecturers were

assimilationists, and the failure to incorporate Indians into the United States was one source of their anguish. Even so, they challenged their audiences' preconceptions about Native people. As motion pictures, radio, and television began to replace lecture circuits in the twentieth century, public opportunities for Indians to voice their concerns personally waned, but the rise of modern Indian activism in the 1970s returned Native people to the podium, especially on university campuses.

Published life stories reached a broader audience than lectures. Winnemucca wrote her memoir, *Life Among the Piutes* (1883), in order to provide details of Paiute suffering at the hands of those pledged to protect them. Boarding school experiences provided subject matter for other books including Francis La Flesche's *The Middle Five* (1900). In 1900, Zitkala-Ša began writing for the *Atlantic Monthly*, a periodical with a non-Indian readership, and in 1921 she collected her essays, many of which focused on her trying encounters with the non-Indian world, in *American Indian Stories*. Native writers dramatized injustice by challenging stereotypes of Indians and depicting their cultures in a positive way. The physician and activist Charles Eastman, for example, wrote sympathetically about his Sioux upbringing in *Indian Boyhood* (1902). Although these assimilationists saw little future for the societies into which they had been born, autobiographers still expressed appreciation and nostalgia for them.

The rise of museums and the advent of anthropology as an academic discipline in the late nineteenth century brought ethnographers to Indian country. They often had little training or knowledge, but they enthusiastically embraced the task of recording what they believed were the remnants of dying cultures. A number of them, such as Gilbert Wilson, recorded and published "as told to" autobiographies of Native people. Wilson first visited the Fort Berthold Reservation in North Dakota in 1906, and over the next dozen years, he recorded the Hidatsa way of life. In addition to monographs issued by the American

Museum of Natural History, Wilson published "autobiographies" of his chief informants, Edward Goodbird (1914) and his mother Waheenee, or Buffalo Bird Woman (1921). The tone of such works differs from life stories over which Indian authors had more control. In quiet resignation and without bitterness, for example, Waheenee concludes hers (or Wilson's), "Our Indian life, I know, is gone forever." John Neihardt, author of the popular *Black Elk Speaks* (1932), even claimed authorship of the story the Sioux medicine man told. "As told to" autobiographies continue to be written, but modern standards of ethnographic research and ethics mean that they more accurately reflect the views of their subjects/authors. *Mountain Wolf Woman, Sister of Crashing Thunder: The Autobiography of a Winnebago Indian* (1961), edited by anthropologist Nancy Oestreich Lurie, is a good example. A number of public figures have written autobiographies with the aid of journalists or other professional writers. These more closely resemble the first generation of Native autobiographies in that they are often highly political. Among the best is Mary Brave Bird (originally published under Mary Crow Dog), *Lakota Woman* (1990), which was made into a movie in 1994.

Native newspapers and periodicals challenged the assumptions of non-Indians about Indians. In 1851 George Copway, a Canadian Ojibwe, briefly published *Copway's American Indian*, in New York, but a national Indian press emerged out of the reform movements at the turn of the century. Indian assimilationists founded the Society of American Indians in 1911, and that organization's publications, *Quarterly Journal* (1913–15), followed by the *American Indian Magazine* (1916–20), provided a national forum for advocacy. Passions ran high among these committed Native reformers, and one of the founders, physician Carlos Montezuma, left SAI and began his own newsletter *Wassaja* (1916–22). The National Congress of American Indians, founded in 1944, issued a newsletter followed in the 1960s by the *Sentinel*, which became important forces in American Indian policy.

The Red Power movement in the 1970s gave rise to more radical news outlets. Foremost was *Akwesasne Notes*, which emerged from Canadian attempts to regulate Mohawk movement from one part of their reservation to another across an international boundary and became the voice of Red Power. Today a number of newspapers, including *Indian Country Today* and *News from Indian Country*, keep the public informed about issues affecting Native people.

Tribal newspapers primarily have a local readership, but in the nineteenth century they had a wider audience and sought to influence national Indian policy. The *Cherokee Advocate*, successor to the *Cherokee Phoenix*, began publication in 1844 following removal, and by the end of the century, the Territory had enough newspapers that publishers formed the Indian Territorial Press Association. Several were bilingual. The vast majority of Indian Territory newspapers, unlike the *Advocate*, were not tribally owned, and they publicized a wide range of views on issues such as allotment and statehood. Most ceased publication after allotment and Oklahoma statehood in 1907, but elsewhere Indians were beginning to publish newspapers. That trend accelerated after World War II, in part because Indian Reorganization provided a political structure in many tribes that could support newspaper publication but also because Indians began to be more politically active on a local level. In 1970 the American Indian Press Association organized to provide a news service and address issues common to Indian newspapers, such as freedom of the press, but it collapsed in 1975 for lack of funding. Journalists continue to meet occasionally, and in 1984 they founded the Native American Press Association, renamed Native American Journalists Association in 1990. That organization monitors the coverage of Indians in mainstream newspapers and addresses issues such as the use of Indian mascots by sports teams. Tribal newspapers have grappled with freedom of the press on Indian reservations, a troubling issue since tribal governments own many newspapers and sometimes object to unfavorable coverage.

Native journalism has a longer history than creative writing, but in the twentieth century American Indian writers have garnered accolades, including a Pulitzer Prize awarded to the Kiowa novelist N. Scott Momaday. The first novel by an American Indian was *Joaquin Murieta* (1854) by John Rollin Ridge, a Cherokee. The subject is a Mexican-American outlaw in California, but the circumstances that drove Murieta to crime parallel U.S. dispossession of the Cherokees and other Native peoples. The Creek writer Alice Calplahan wrote *Wynema* (1891), the first Indian-authored novel that openly addressed Native issues. Set in Indian Territory during allotment, the novel links two injustices—Indian dispossession and gender inequality—and attributes both to white domination. *Queen of the Woods* (1899), attributed to Simon Pokagon, a Potawatomi, was a nostalgic, fictionalized account of the author's youth that pointed to alcohol as yet another destructive consequence of Indian contact with whites.

Written fiction, poetry, and drama stem from a European cultural tradition, not a Native one. In Native societies oral traditions pass from one generation to another with each teller bringing to it his or her own experiences. The audience contributes through responses and interjections. Consequently, oral traditions embody a communal dynamic that individual writers have tried to capture by infusing their writings with a sense of the cultural context. Ella Cara Deloria uses Sioux social organization to frame her classic novel *Waterlily* (completed in the 1940s but published 1988). Following a set of social conventions very different from anything most readers have experienced, her characters nevertheless are compelling, and their society, which at first seems incomprehensible, becomes intelligible and appealing. In James Welch's historical novel *Fools Crow* (1986), a band of warriors violate Blackfeet ethics by putting the individual ahead of the community, and they threaten to disrupt a social system rooted in reciprocity and mutual respect. Welch draws the reader into Blackfeet society, in part by using literal English translations

for Blackfeet words, and thereby is able to convey effectively the horror that emerges from their contact with whites.

Characters struggle with questions of identity that are rooted in the past. Because of their personal histories and the more general Native experience of colonization, characters find themselves, as writer and literary critic Louis Owens phrased it, "between realities." They must struggle to recover "a continuing and coherent cultural identity." Two of the most memorable characters in Native fiction, Abel in Momaday's *House Made of Dawn* (1968) and Tayo in Leslie Marmon Silko's *Ceremony* (1977) return from World War II to their New Mexico reservations with heavy psychic burdens. Fueled by alcohol, Abel commits murder, goes to prison, then moves in Los Angeles, and finally returns to the reservation to find hope in the ancient rites he performs upon his grandfather's death. Tayo suffers from guilt over his cousin's death on the Bataan death march and turns to alcohol, which only deepens his despair. Traditional medicine does not cure him, but hope comes from a woman who introduces him to the healing power of the earth's bounty and a medicine man who has revitalized ancient rituals to deal with modern problems such as alcoholism. Characters in many Native novels are not only the product of their personal pasts but of a long history of dispossession and oppression. In poetry, too, past and present commingle. In *She Had Some Horses* (1983) the Creek poet Joy Harjo drew on the Oklahoma landscape, historical events, ancient cultural traditions, and the experiences of Indians far from home to explore the struggles that confront modern Indians and the strength they draw from their cultural traditions.

Mixed race people are another legacy of colonization. The experiences of "mixed blood" people become an allegory for the place of Indians in American society. Mourning Dove of the Colville Confederated Tribes presented the dilemma that people between two cultures face in *Cowegea, the Half-Blood* (1927). The title character ultimately is scorned by her white lover and finds happiness with someone like herself, a person who belongs

123

with neither white nor red. Happiness living between two cultures eludes other "mixed blood" characters. In *Sundown* by John Joseph Mathews, an Osage writer, white marriages to Osages jeopardize not just their oil fortunes but also their culture. And in *The Surrounded* by D'Arcy McNickle, whom the Flathead tribe adopted, the impossibility of straddling cultures becomes clear. Subsequent writers continue to employ "mixed blood" characters, but they tend to agonize less about personal identity. These characters provide opportunities to indict racism and demonstrate the vitality of Native culture, but reflecting the political activism of the 1970s and beyond, writers focus on issues of tribal and cultural sovereignty.

Native characters are not automatons, following a clearly charted course. They make choices, and authors use those choices to dramatize the complexity of Native culture and history. Susan Power in *Grass Dancer* (1994) imbues two of her characters with great spiritual power. Mercury Thunder uses that power for her own self-aggrandizement while Herod Small War guides a young man on a spiritual journey that brings community reconciliation. The past, in the form of very real figures, converges with the present in an almost cyclical narrative. In LeAnne Howe's *Miko Kings: An Indian Baseball Story* (2007), Hope Little Leader's decision to throw a baseball game has disastrous consequences for him as well as his team. His experience serves as a metaphor for the dismemberment of the Oklahoma Indian nations on the eve of statehood. Despite bad decisions, redemption is possible for some characters. In *Grass Dancer*, Mercury's granddaughter does not follow in her footsteps, and Hope gets an opportunity to replay the fateful game in *Miko Kings*.

Trickster characters in Native writing defy time and space and signal readers that there is a different reality than the one to which they are accustomed. Tricksters appear in the oral traditional literature of most Native peoples, and they are shape-shifters to whom the normal rules do not apply. They cause problems

for other characters, but they also are frequently the source of creation or transformation. In modern literature, they often challenge colonization. Gerald Vizenor's *Darkness in Saint Louis Bearheart* (1978) features a trickster, a "crossblood" (biracial) shaman who leads a pilgrimage fraught with upsets and challenges, but ultimately results in self-realization and a profound understanding of the dynamic nature of culture and identity. Gerry Nanapush in Louise Erdrich's *Love Medicine* (1984) is a trickster figure, escaping repeatedly from jail and causing problems in his community, just like the trickster of the Ojibwe culture in which Erdrich's novels are rooted. Gerry's son Lipsha Morrissey is also a trickster. He seeks to reconcile his adoptive parents only to accidentally kill his grandfather, but his medicine brings about another kind of reconciliation, one between his adoptive mother and his biological grandmother. Lipsha's discovery of his real parentage, his true identity, is empowering, and he helps his father escape to Canada. *Love Medicine* invokes a sense of community and continuity by giving each chapter a different narrator and by moving back and forward in time, techniques other Native writers use.

Like literature, American Indian art often reaches into the past for themes. The distinction between art and craft long consigned Native basketry, pottery, jewelry, and weaving to the latter category, the production of "primitives" rather than "civilized" artists. The arts and crafts movement stimulated appreciation for Native arts, and in this context, American Indian painting began to develop a following. Indians had long painted, most prominently the pictorial calendars, called winter counts, and the ledger art produced by plains warriors. Following World War I, painters who had studied at the Santa Fe Indian School or at the Kiowa Agency in Oklahoma gained national attention. The use of bright colors, strong outlines, and solid backgrounds in paintings that depicted traditional cultural practices, including ceremonies that the OIA had banned, came to characterize this "traditional" style of Indian painting. The artists' sensitive depictions of their cultures

challenged stereotypes of Indian "savagery." Modern artists have moved away from this traditional style, but their cultural roots and historical experiences are still evident. So sometimes is their humor. Bob Haozous's sculpture *Apache Pull-Toy* (1988) is a large painted steel cowboy mounted on wheels and riddled with bullets.

10. Bob Haozous, *Apache Pull-Toy* (1988). This large sculpture expresses anger, irony, and humor.

Indian representations of themselves and their cultures often stand in stark contrast to the dominant culture's depiction of them. Dime novels, which became popular in the 1850s, made Indians stock villains, a category they shared with outlaws. When Buffalo Bill initiated his Wild West shows in 1883, he embraced the Indian fighter persona of the dime novels, and the Indians who appeared in his shows played to stereotype. "Indian songs," which became popular in the 1890s, often presented Indians as comic characters. "Rain-in-the-Face," the name of the warrior who supposedly killed Custer, was about a drunk: "He used to chase all over the place, Buy him a drink and you were an ace." In the early twentieth century, athletic teams began adopting "Indian" mascots—Braves, Redskins, Chiefs, and others—that caricatured Native people. Among the earliest silent films were Westerns in which the timely arrival of the cavalry, cowboys, or Buffalo Bill saved supposedly innocent whites from Indian massacre. In *The Battle at Elderbush Gulch* (1913), released two years before *The Birth of a Nation*, D. W. Griffith tried out the theme with Indians instead of African Americans as the savage threat to white womanhood. By the 1950s, such depictions of Indians were a staple of movies and television shows. Even when they were not the villains, Indians had roles that were subservient to whites, most notably the Mohawk actor Jay Silverheels playing the Lone Ranger's sidekick Tonto.

Indians countered these images in political discourse, especially from the 1970s, and they began to bring their own representations of Indians to popular culture. Indians had long performed as musicians and dancers—ballerina Maria Tallchief, an Osage, made Stravinsky's *Firebird* her own, and Robbie Robertson, a Mohawk, entered the Rock and Roll Hall of Fame as lead guitarist for The Band—but identifiable Native elements have been difficult to discern. The relocation of Indians from reservations to cities in the 1950s sparked the modern pan-Indian powwow movement, which introduced many non-Indians to Native music and dance. The American Indian Dance Theatre, founded in 1987 by Hanay Geiogamah, a Kiowa/Delaware, draws from many Native cultures

to produce music and dance performances for modern audiences. In the 1980s Carlos Nakai, who has Navajo and Ute ancestry, won national recognition with his American Indian flute. Music with Native American roots has become so popular that in 1998, the Native American Music Association began holding its own annual ceremony at which it presented Nammy Awards. Recognizing the crossover appeal of this music, in 2001 the Recording Academy, which makes the Grammy awards, instituted the category Best Native American Music Album.

Self-representations of Native people in film came slowly. Produced by non-Indians, the television series *Northern Exposure* (1990–95), employed a number of Indian actors, including Elaine Miles, an Umatilla who won acclaim as Marilyn Whirlwind, and depicted Natives as integral to the small Alaska town despite their distinct cultures. The first Native film to achieve both critical acclaim and a broad audience in the United States was *Smoke Signals* (1998) based on Spokane/Coeur d'Alene Sherman Alexie's collection of short stories, *The Lone Ranger and Tonto Fistfight in Heaven* (1993). Directed by Chris Eyre, a Cheyenne/Arapaho, the film follows two young Coeur d'Alene men as they travel from Idaho to Arizona to collect the ashes and settle the estate of one of their fathers. On the journey they reconcile with each other as well as the past, which links them as inextricably as it threatens to divide them. The characters are multidimensional and live in a world of traffic reports, basketball, and T-shirts, but they are undeniably Indian. *Smoke Signals* is full of humor, but it is Indian humor born of a specific view of the world.

At the beginning of the twenty-first century, Native people have asserted cultural sovereignty not only for the right to represent themselves but also for the right to control their cultural patrimony. Most Indian tribes require formal permission for scholars to conduct research on their reservations, and they are insistent that research benefit the people who are its subjects. In 1990 Congress passed the Native American Graves Protection and Repatriation

Act, which requires that archaeologists return human remains and funerary objects discovered on federal land to culturally affiliated tribes. The act also compelled universities and museums to catalog their collections and give skeletal and sacred artifacts back to the Native peoples from whom they came. Compliance is often difficult because of the age of the artifacts and the dislocation of Indian tribes. Sometimes ownership is unclear. In 1996 the discovery of skeletal remains, now known as Kennewick man, on a Columbia River bank in Washington set off a court battle between archaeologists and local Indian tribes who claimed the remains. A 2004 court decision found for the archaeologists on the grounds that the Indians could not prove their kinship to the approximately eight-thousand-year-old remains. This setback should not obscure the many victories Native peoples have won in securing the return of their ancestors' remains and their sacred objects.

The material culture of Native peoples often found its way to museums controlled by non-Indians. In recent years, many tribes have decided that interpreting their cultures and histories according to their own purposes is an important expression of cultural sovereignty. One of the most remarkable achievements is the Makah museum in far northwest Washington. A partnership between the tribe and academic archaeologists produced a treasure of centuries-old artifacts that explains their history as whale hunters. Filling contemporary Makahs with pride in their past, the objects on display have proved invaluable in documenting before the courts their ancient technologies and securing for them the right once again to hunt whales. On a much grander scale, the tribes have cooperated in the design, construction, organization, and financing of the National Museum of the American Indian (NMAI), a part of the Smithsonian Institution in Washington. NMAI is both a place where tribes celebrate their separate histories and a monument to the totality of Native America.

Indian tribes also have exercised their cultural sovereignty by asserting control over education. Until the 1970s the Bureau

of Indian Affairs provided schools on Indian reservations, but since then, many tribes have begun to operate their own schools. This move has given tribes the opportunity to include their own culture, history, and language in the curriculum and to serve their own needs. Reclamation projects are underway in many Native communities as tribes rush to preserve oral traditions and histories and to revitalize languages that are in danger of disappearing. They have found corporate and academic help. Rosetta Stone, Inc. works with tribes to develop language learning systems, including one for Chitimacha, a Louisiana language whose last Native speaker died in 1940. From the University of Alaska Southeast, where students can minor in Tlingit, to Western Carolina University, where students learn Cherokee, academic linguists and Native speakers work together on language preservation. Beyond cultural revitalization, tribal colleges give students an opportunity to learn skills that tribes need, and because they are located on reservations, they increase the likelihood that graduates will remain in the community. The Navajo Nation established the first tribal college in 1968, and in 2009, there are more than thirty in twelve states.

Cultural sovereignty is possible because, since the 1970s, Native people have expanded their exercise of tribal sovereignty and they have gained a degree of economic autonomy. As long as Indian tribes were powerless, non-Indians could use Native images for their own purposes. In the last quarter of the twentieth century, however, Indian people empowered themselves through political activism and economic development. We can see the result of these efforts in literature, the arts, popular culture, and education. At the beginning of the twenty-first century, Indian people speak for themselves.

Further reading

General studies and overviews

Calloway, Colin G. *First Peoples: A Documentary Survey of American Indian History*. Boston: Bedford/St. Martin's, 2008.

Deloria, Philip J., and Neal Salisbury, eds. *A Companion to American Indian History*. Malden, MA: Blackwell Publishers, 2002.

Duthu, N. Bruce. *American Indians and the Law*. New York: Penguin, 2008.

Edmunds, R. David, Frederick E. Hoxie, and Neal Salisbury. *The People: A History of Native America*. Boston: Houghton Mifflin, 2007.

Hoxie, Frederick E., ed. *Encyclopedia of North American Indians: Native American History, Culture, and Life from Paleo-Indians to the Present*. Boston: Houghton Mifflin, 1996.

Sturtevant, William C., ed. *Handbook of North American Indians*. 20 vols. Washington, DC: Smithsonian Institution Press, 1978–2008.

Trigger, Bruce G., and Wilcomb E. Washburn, eds. *The Cambridge History of the Native Peoples of the Americas*. Vol. 1. Cambridge: Cambridge University Press, 1996.

Chapter 1

Deloria, Ella. *Speaking of Indians*. Lincoln: University of Nebraska Press, 1998.

Fagan, Brian M. *Ancient North America: The Archaeology of a Continent*. 3rd ed. London: Thames and Hudson, 2000.

Kehoe, Alice Beck. *America Before the European Invasions*. New York: Longman, 2002.

Reid, John Phillip. *A Law of Blood: The Primitive Law of the Cherokee Nation*. New York: New York University Press, 1970.

Thomas, David Hurst. *Skull Wars: Kennewick Man, Archaeology, and the Battle for Native American Identity*. New York: Basic Books, 2002.

Thornton, Russell. *American Indian Holocaust and Survival: A Population History Since 1492*. Norman: University of Oklahoma Press, 1987.

Chapter 2

Braund, Kathryn E. Holland. *Deerskins and Duffels: The Creek Indian Trade with Anglo-America, 1685–1815*. Lincoln: University of Nebraska Press, 1993.

Gallay, Alan. *The Indian Slave Trade: The Rise of the English Empire in the American South, 1670–1717*. New Haven, CT: Yale University Press, 2002.

Richter, Daniel K. *The Ordeal of the Longhouse: The Peoples of the Iroquois League in the Era of European Colonization*. Chapel Hill: University of North Carolina Press, 1992.

Rountree, Helen C. *Pocahontas's People: The Powhatan Indians of Virginia Through Four Centuries*. Norman: University of Oklahoma Press, 1990.

Trigger, Bruce G. *Natives and Newcomers: Canada's "Heroic Age" Reconsidered*. Kingston and Montreal: McGill-Queen's University Press, 1985.

White, Richard. *The Middle Ground: Indians, Empires, and Republics in the Great Lakes Region, 1650–1815*. Cambridge: Cambridge University Press, 1991.

Williams, Robert A. *The American Indians in Western Legal Thought: Discourses of Conquest*. New York: Oxford University Press, 1990.

Chapter 3

Bowes, John P. *Exiles and Pioneers: Eastern Indians in the Trans Mississippi West*. Cambridge: Cambridge University Press, 2007.

Dowd, Gregory Evans. *A Spirited Resistance: The North American Indian Struggle for Unity, 1745–1815*. Baltimore: Johns Hopkins University Press, 1992.

Edmunds, R. David. *The Shawnee Prophet*. Lincoln: University of Nebraska Press, 1983.

Horsman, Reginald. *Expansion and American Indian Policy, 1783–1812*. East Lansing: Michigan State University Press, 1967.

Perdue, Theda. *Cherokee Women: Gender and Culture Change, 1700–1835*. Lincoln: University of Nebraska Press, 1998.

Wallace, Anthony F. C. *The Long Bitter Trail: Andrew Jackson and the Indians*. New York: Hill and Wang, 1993.

Chapter 4

Calloway, Colin G. *One Vast Winter Count: The Native American West before Lewis and Clark*. Lincoln: University of Nebraska Press, 2003.

Hamalainen, Pekka. *The Comanche Empire*. New Haven, CT: Yale University Press, 2008.

Hanson, James A. *When Skins Were Money: A History of the Fur Trade*. Chadron, NE: Museum of the Fur Trade, 2005.

Isenberg, Andrew C. *The Destruction of the Bison: An Environmental History, 1750–1920*. Cambridge: Cambridge University Press, 2000.

Ostler, Jeffrey. *The Plains Sioux and U.S. Colonialism from Lewis and Clark to Wounded Knee*. Cambridge: Cambridge University Press, 2004.

Swagerty, William R. "Indian Trade in the Trans-Mississippi West to 1870." In *History of Indian-White Relations*, edited by Wilcomb E. Washburn. Vol. 4 of *Handbook of North American Indians*, edited by William C. Sturtevant, 351–74. Washington, DC: Smithsonian Institution, 1988.

Weber, David J. *The Spanish Frontier in North America*. New Haven, CT: Yale University Press, 1992.

Chapter 5

Adams, David Wallace. *Education for Extinction: American Indians and the Boarding School Experience, 1875–1928*. Lawrence: University Press of Kansas, 1995.

Debo, Angie. *And Still the Waters Run: The Betrayal of the Five Civilized Tribes*. Princeton, NJ: Princeton University Press, 1940.

Hoxie, Frederick E. *A Final Promise: The Campaign to Assimilate the Indians, 1880–1920*. Lincoln: University of Nebraska Press, 1984.

LaFlesche, Francis. *The Middle Five: Indian Schoolboys of the Omaha Tribe*. Lincoln: University of Nebraska Press, 1963.

McDonnell, Janet A. *The Dispossession of the American Indian, 1887–1934*. Bloomington: Indiana University Press, 1991.

Prucha, Francis Paul. *American Indian Policy in Crisis: Christian Reformers and the Indian, 1865–1900*. Norman: University of Oklahoma Press, 1976.

Standing Bear, Luther. *My People the Sioux*. Lincoln: University of Nebraska Press, 1975.

Zitkala-Ša. *American Indian Stories*. Lincoln: University of Nebraska Press, 1985.

Chapter 6

Harvard Project on American Indian Economic Development. *The State of the Native Nations: Conditions under U.S. Policies of Self-Determination*. New York: Oxford University Press, 2008.

Frantz, Klaus. *Indian Reservations in the United States: Territory, Sovereignty, and Socioeconomic Change*. Chicago: University of Chicago Press, 1999.

Light, Steven Andrew, and Kathryn R. L. Rand. *Indian Gaming and Tribal Sovereignty: The Casino Compromise*. Lawrence: University Press of Kansas, 2005.

Parman, Donald L. *Indians and the American West in the Twentieth Century*. Bloomington: Indiana University Press, 1994.

Philp, Kenneth R. *Termination Revisited: American Indians on the Trail to Self-Determination, 1933–1953*. Lincoln: University of Nebraska Press, 1999.

Prucha, Francis Paul. *The Great Father: The United States Government and the American Indians*. Lincoln: University of Nebraska Press, 1984.

Wilkinson, Charles. *Fire on the Plateau: Conflict and Endurance in the American Southwest*. Washington, DC: Island Press, 1999.

Chapter 7

Berkhofer, Robert F. Jr. *The White Man's Indian: Images of the American Indian from Columbus to the Present*. New York: Random House, 1978.

Deloria, Philip. *Indians in Unexpected Places*. Lawrence: University Press of Kansas, 2004.

Kilpatrick, Jacqueline. *Celluloid Indians: Native Americans and Film*. Lincoln: University of Nebraska Press, 1999.

Murphy, James Emmett, and Sharon Murphy. *Let My People Know: American Indian Journalism, 1828–1978*. Norman: University of Oklahoma Press, 1981.

Owens, Louis. *Other Destinies: Understanding the American Indian Novel*. Norman: University of Oklahoma Press, 1992.

Penney, David W. *North American Indian Art*. New York: Thames & Hudson, 2004.

Index